SIGNALLING AND SIGNAL BOXES

Along the GER Route

Allen Jackson

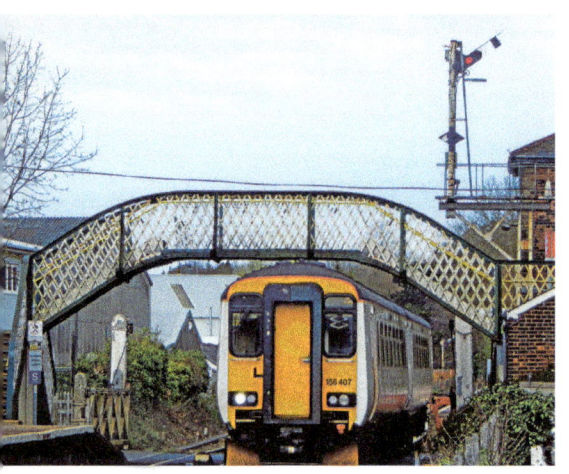 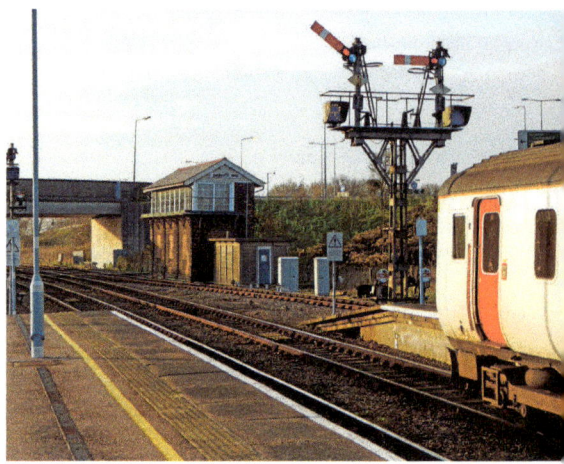

Above left: Class 156 DMU 156 407 heads for Great Yarmouth from Brundall. (April 2015)

Above right: Class 156 DMU 156 407 heads from Great Yarmouth for Reedham Junction. (April 2015)

For Ninette.

First published 2017

Amberley Publishing
The Hill, Stroud,
Gloucestershire, GL5 4EP

www.amberley-books.com

Copyright © Allen Jackson, 2017

The right of Allen Jackson to be identified as the Author of this work has been asserted in accordance with the Copyrights, Designs and Patents Act 1988.

All rights reserved. No part of this book may be reprinted or reproduced or utilised in any form or by any electronic, mechanical or other means, now known or hereafter invented, including photocopying and recording, or in any information storage or retrieval system, without the permission in writing from the Publishers.

ISBN: 978 1 4456 6752 2 (print)
ISBN: 978 1 4456 6753 9 (ebook)

British Library Cataloguing in Publication Data.
A catalogue record for this book is available from the British Library.

Typeset in 10pt on 13pt Celeste.
Typesetting by Amberley Publishing.
Printed in the UK.

Contents

Introduction	5
Signal Boxes and Infrastructure on Network Rail	7
Summary of Contents	11
Great Eastern Railway (GER)	13
References and Acknowledgements	96

Introduction

Up until 1 January 1923 there were hundreds of railway companies in Britain. The government at the time perceived an administrative difficulty in controlling the railways' activities at times of national crisis. The country had just endured the First World War and the political feeling was that it could all be managed better if they were amalgamated; thus came the railway 'grouping', as it was termed.

The London and North Eastern Railway was one of the four constituents but the identity of the larger companies persisted and does so to this day. Lines are referred to by their pre-grouping ownership by Network Rail and others even now.

Many of the smaller companies did lose their identity, in signalling terms, although their architecture may remain.

The only pre-grouping railways considered, therefore, are those for which an identifiable signalling presence existed at the time of the survey.

The ex-LNER signalboxes and infrastructure has been split into six volumes:

Great Eastern Railway (GER)
Great Northern Railway (GNR)
Great Central Railway (GCR)
North Eastern Railway (NER) Parts 1 and 2
The LNER in Scotland and Cheshire and the North West of England

The LNER is most popularly remembered by the Railway Races to the North in the 1870s and trains like the *Flying Scotsman*.

The GER got as far north as Lincolnshire but mostly occupied Essex, Cambridgeshire, Suffolk and Norfolk.

The major centres have had their signalling updated since the 1960s and so it is only the secondary lines and branches that tend to operate mechanical signalling. That said there were considerable stretches of line under the semaphore, but recent years have seen, particularly in East Anglia, a further modernisation such that not much mechanical signalling exists there now. However, the survey there predates the recent cull.

In this book the system of units used is the imperial system, which is what the railways themselves still use, although there has been a move to introduce metric units in places like the Railway Accident Investigation Branch reports and in the south-east of England where there are connections to the Channel Tunnel. Distances and quantities will have a conversion to metric units in brackets after the imperial units used:

1 mile = 1.6 kilometres, 1 yard = 0.92 metres, 1 chain = 22.01 metres, 1 chain = 22 yards, 1 mile = 1,760 yards or 80 chains.

Signal Boxes and Infrastructure on Network Rail

The survey was carried out between 2003 and 2015 and represents a wide cross-section of the remaining signal boxes on Network Rail. Inevitably some have closed and been demolished; others have been preserved and moved away since the survey started. The large numbers of retired or preserved signalling structures have not been considered in this work.

Although the book is organised around the pre-grouping companies, the passage of time has meant that some pre-grouping structures have been replaced by LNER or BR buildings.

If you are intending visiting any of them it is suggested that you find out what the current status is before you set off.

For reasons of access and position, some signal boxes are covered in greater detail than others and some are featured as a 'focus on' where the quality of the information or the interest of that location merits that attention.

Some of the signal boxes have been reduced in status over the years, and whilst they may have had controlled block sections or main lines in the past, some no longer do so but are – or were at the time of the survey – on Network Rail's payroll as working signal boxes.

Details of the numbers of levers are included but not all the levers may be fully functional as signal boxes have been constantly modified over the years.

Lever colours are:

RED –	Home Signals
YELLOW –	Distant Signals
BLACK –	Points
BLUE –	Facing Point Locks
BLUE/BROWN –	Wicket gates at level crossings or locks
BLACK/YELLOW CHEVRONS –	Detonator placers (no longer used but some boxes retain the levers)
WHITE –	Not in use – spare
GREEN –	King Lever to cancel locking when single line box switched out

Levers under the block shelf or towards the front window normally are said to be normal and those pulled over to the rear of the box are said to be reversed. There are some boxes where the levers are mounted the opposite way round – in other words, levers in the normal position point to the rear wall, but the convention remains the same.

Listed Buildings
Many signal boxes are considered to have architectural or historic merit and are Grade 2 listed by Historic England. This basically means they cannot be changed externally without permission. If the owner allows the building to decay to such an extent that it is unsafe, the building can then be demolished. The numbers of signal boxes with a listing have increased on the news that remaining mechanical signalling is under sentence.

A Grade 1 listing would require the interiors to remain the same, so that is unlikely to happen with Network Rail structures, but it may happen with the preservation movement – many of whom have preserved the interiors as fully operational working museums.

Signal Box Official Abbreviation
Most signal boxes on Network Rail have an official abbreviation of one, two, or sometimes three letters. This usually appears on all signal posts relevant to that box. The abbreviation for each box appears after the box title in this book, if it has one.

Signal Box Official Title
The signal box title contained in the original act of parliament for the line has been used. As state education for most was not available until the 1850s, some of the titles were drafted by clerks who were either ill-educated or had received no education at all. Consequently, grammar and punctuation are sometimes present and sometimes not.

Ways of Working

Absolute Block – AB
A concept used since railways began almost is the 'block' of track where a train is permitted to move from block to block, provided no other train was in the block being moved to. This relies on there being UP and DOWN tracks. Single lines have their own arrangements. It is usual to consider trains travelling in the UP direction towards London, but there are local variations and this is made clear in the text.

This block system was worked by block instruments that conveyed the track occupancy status and by a bell system that was used to communicate with adjacent signal boxes.

The signallers rely on single stroke bells for box-to-box communication. Although this is supplemented by more modern means, the passage of trains is still controlled by this means. A typical communication for the passage of an express passenger train (Network

Rail Class 1) from signal box A to signal box B would be as follows (the text in **bold** is the instigator and that in plain text the reply):

Signal Box A		Signal Box B	
Activity	Bell Code	Activity	Bell Code
Call Attention	1	Acknowledge	1
Line clear for Express?	4	Acknowledge Line is clear for Express	4
Train entering block section	2	Acknowledge Train entering block section	2
Acknowledge Train leaving block section	2.1	**Train leaving block section**	2.1

Each time an activity is done, the situation as to the position of the train is reflected by block instruments by the signaller at Signal Box B, who is the receiving box. All selections are reflected on Signal Box A's instrument.

The status of a block can be one of the following:

NORMAL – Line Blocked
GREEN – Line Clear
RED – Train on Line

This procedure is repeated along the line to subsequent signal boxes. The absolute block system refers to double lines and the above procedure is for one line of track only. With double track it is not unusual to have two sets of dialogue between adjacent boxes as trains pass each other on separate lines.

In our example, although only the UP line has been shown, a train could be travelling from A to B on the UP line and another train on the DOWN line travelling from B to A.

Track Circuit Block – TCB

Track circuit block is really all to do with colour light signals that are, strictly speaking, outside the scope of this book, except that many signal boxes interface to track circuit block sections and will have track circuit block equipment or indications in signal boxes.

Originally, track circuits lit a lamp in a signal box to indicate where a train was. They worked by passing a small current through track that was electrically insulated at the end of the track circuit; the presence of a train would short-circuit the track and cause a lamp to light in a signal box. Then track circuits were used to interlock block instruments, signals, and points together, to provide a safe working semaphore signal environment. Originally they used DC circuits with batteries, but long sections of welded track has meant that AC of differing frequencies is used. The system knows where the train is by which frequency circuit has been affected.

With colour light signals it is possible to provide automatically changing signals that are controlled by the passage of trains or presence of vehicles on the track. The Train Out of

Section of AB working can be technologically acquired by the use of axle counters; if the number of axles entering a section equals the number leaving it then the train must be complete, and that is what Train Out of Section is saying.

Single Line Workings
Key Token, Tokenless Block and No Signaller Key Token, One Train Working, One Train Staff, Radio Electronic Token Block.
 These are covered in detail in the section on the signal box that supervises such workings.

Summary of Contents

Great Eastern Railway (GER)

PETERBOROUGH to KING'S LYNN
Kings Dyke
Whittlesea
Three Horse Shoes
March East Junction
March South Junction
Stonea
Manea
Littleport
Downham Market
Magdalen Road
King's Lynn Junction

ELY to YARMOUTH VAUXHALL
Shippea Hill
Lakenheath
Brandon
Thetford
Harling Road
Eccles Road
Attleborough
Spooner Row
Wymondham
Brundall
Acle
Yarmouth Vauxhall

CANTLEY to IPSWICH
Cantley
Reedham Junction
Reedham Swing Bridge
Somerleyton Swing Bridge
Oulton Broad North Station
Lowestoft
Oulton Broad South
Saxmundham
Ranelagh Road Crossing, Ipswich

ELY to STOWMARKET
Dullingham
Chippenham Junction
Kennett
Bury St Edmunds Yard
Stowmarket

COLCHESTER to CLACTON
East Gate Junction
Alresford Station
Thorrington
Thorpe le Soken
Frinton
Clacton-on-Sea

Great Eastern Railway (GER)

The Great Eastern Railway made its money from the intensive suburban network emanating from London Liverpool Street station into Essex and part of Suffolk. The railway covered the rest of East Anglia and, apart from some major centres and junctions at Norwich, March, and Ely, was a mainly rural concern with many unprofitable branch lines. The poet John Betjeman revelled in their isolation and peace and quiet, but Dr Richard Beeching – who had been tasked with making the railways pay – did not.

However, some of the branch lines survived, and some of the main lines have the charm of branch lines anyway. In later years some of the railway was electrified with the 25 kV system, compatible with East and West Coast Main Lines, so the bucolic and agricultural runs cheek by jowl with the über modern in places.

Some of the mechanical signalling has now (2015) been replaced, but the survey mostly took place before this event. The journey starts in the northern area of Great Eastern influence and proceeds southwards.

Peterborough to King's Lynn

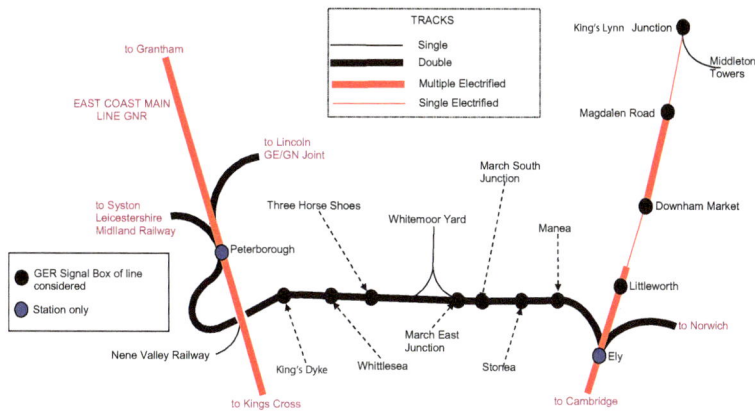

Fig. 3. Peterborough to King's Lynn.

13

A scan of the schematic not-to-scale diagram reveals that this journey mostly heads east across the Cambridgeshire fenland to a massive church that can be seen for miles around; Ely cathedral. Ely is a considerably modernised junction but, north from there to the ancient port of King's Lynn, in Norfolk, is under the wires, with mechanical signal boxes and some single track.

Kings Dyke (K)

Date Built	Type or Builder	No. of Levers	Ways of Working	Current Status 2015	Listed Y/N
circa 1899	GE Type 7 and Dutton Co.	19	TCB, AB	Active	N

As the first Great Eastern box, Kings Dyke has been heavily plasticised and modernised, but just-about retains its GE character despite an extension fitted at the far end in 2004. The box works Track Circuit Block to Peterborough Power Signal Box and Absolute Block to Whittlesea.

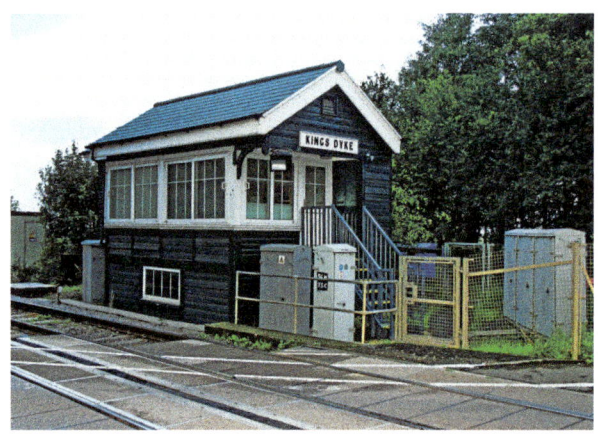

Fig. 4. Kings Dyke signal box. The mileage on the instrument cabinet is the distance the box is from Liverpool Street station via Ely. (October 2006)

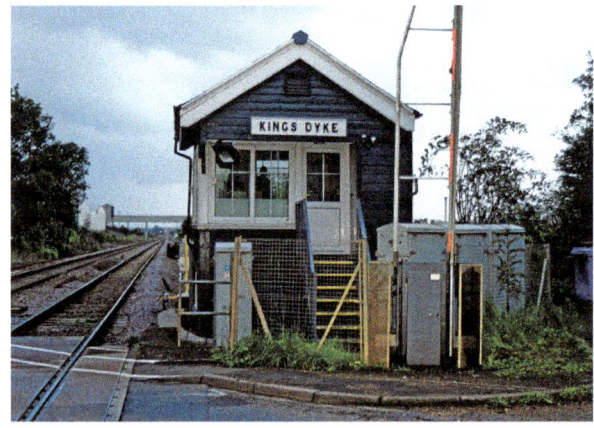

Fig. 5. Kings Dyke signal box looking towards Peterborough and the river Nene. (October 2006)

Kings Dyke signal box is 96 miles and 73 chains (155.97 km) from Liverpool Street station via Ely.

Whittlesea (W)

Date Built	Type or Builder	No. of Levers	Ways of Working	Current Status 2015	Listed Y/N
circa 1887	GE Type 7.	27	AB	Active	N

Whittlesea has changed its name to Whittlesey, possibly to avoid disgruntled rail passengers who thought they were having a day out at the beach. No matter – Whittlesey is a pleasant market town that has seen growth in recent years. Whittlesea station and signal box are still named as such.

The box is the tallest structure around with a good view of the surrounding fens. The box has a sub-box where a crossing keeper just supervises the opening and closing of the manual gates. They are separated by the station platforms.

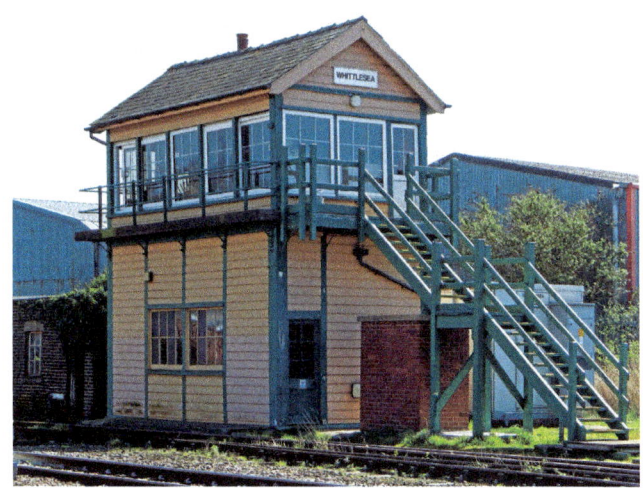

Fig. 6. Whittlesea signal box from the Up platform. (April 2015)

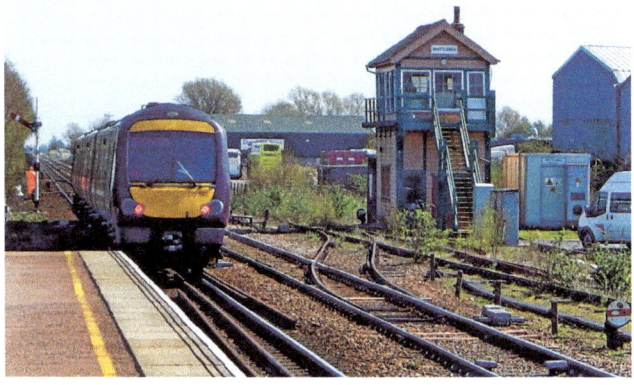

Fig. 7. Whittlesea signal box and class 170, 170 397 rushes past without stopping at Whittlesea, and the next two home signals provide the permission. Note that there is a crossover to sidings on the down side towards Peterborough. The view is towards Ely. (April 2015)

15

Fig. 8. The Down line is towards Peterborough. The station is about as basic as a station gets. There is a track circuited ground disc to signal a reversing move off the Up main line to access the sidings, which are out of use at the survey date. The trailing crossover enables Up trains to access the sidings. The crossing keeper's hut and gates complete the scene. (April 2015)

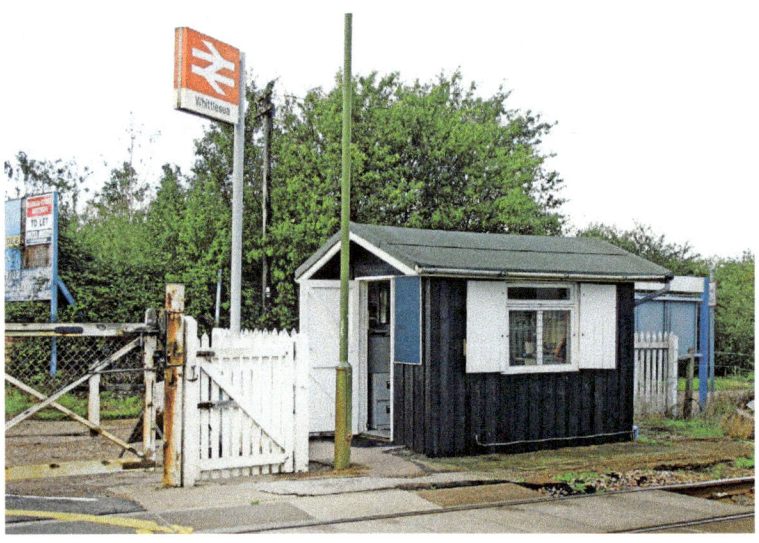

Fig. 9. An earlier version of the Whittlesea crossing keeper's hut for manually opening and closing the gates. The pedestrian wicket gate appears to just have a slip bolt and no mechanical lock with the gates or signalling. (October 2006)

Whittlesea signal box is 94 miles and 55 chains (152.38 km) from Liverpool Street station via Ely.

Three Horse Shoes (THS)

Date Built	Type or Builder	No. of Levers	Ways of Working	Current Status 2015	Listed Y/N
1901	GE Type 7.	30	AB,TCB	Active	N

The Three Horseshoes is the name of a pub in the hamlet of Turves nearby and, like so many, is unoccupied now. The signal box had supervised the junction for the good-only line to Burnt House and Benwick, south across the fens, which closed in 1966. The Great Eastern had opened the branch line in 1899.

Fig. 10. Three Horse Shoes signal box. The splitting up of Horse and Shoes – another faux pas on the original act of parliament – is clearly visible on the box nameplate. The modernisation extends to a galvanised steel staircase but the unit has been extended to form a walkway in front of the first floor windows. No security problem or Luftwaffe raids here, so locking frame room windows are in place. (October 2006)

Fig. 11. Class 158, 158 783 East Midlands DMU hurries past Three Horse Shoes signal box, former goods shed, and loading gauge frame towards Ely. The view is from Burnt House Drove Crossing. Look at the distance between the box and the running lines – a sign that there would have been a loop or sidings here to stable a freight train before it went down the branch line. (April 2015)

17

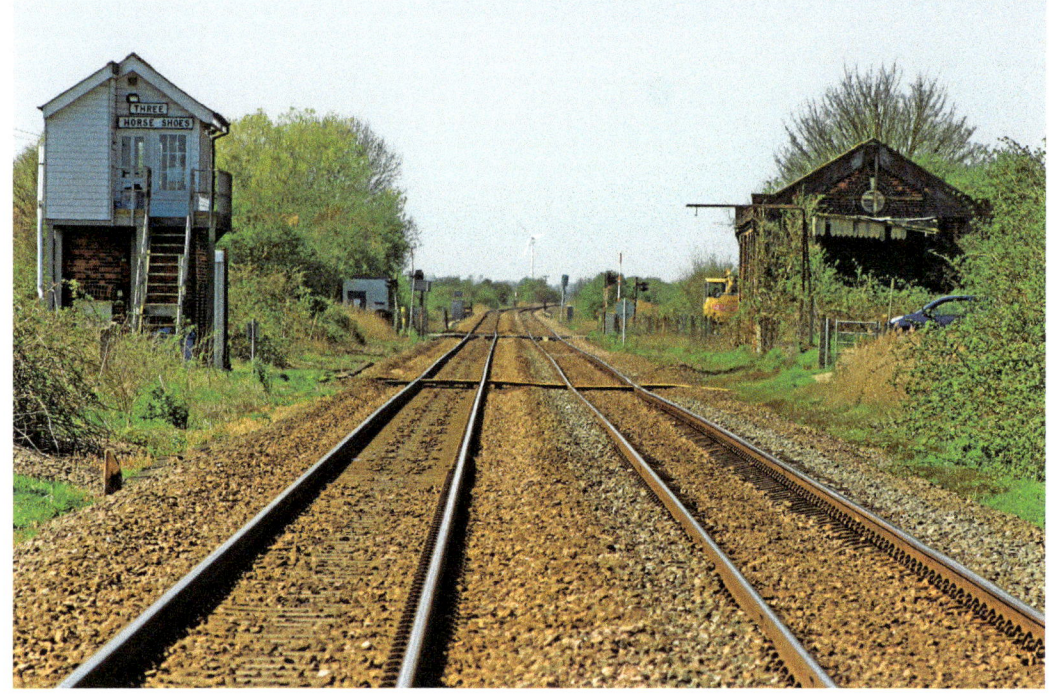

Fig. 12. Three Horse Shoes signal box from March Road crossing towards Burnt House Drove provides the next view at the opposite end of the layout to the previous picture. There are nine crossings in about 6 miles (9.66 km). (April 2015)

Three Horse Shoes signal box is 91 miles and 5 chains (146.55 km) from Liverpool Street station via Ely.

March East Junction (ME)

Date Built	Type or Builder	No. of Levers	Ways of Working	Current Status 2015	Listed Y/N
1885	GE Type 5.	61	AB,TCB	Active	N

March is an ancient market town that relied heavily on agriculture before the coming of the railways.

March was a considerable railway junction, with five separate lines running into it. To service the massive interchange of freight traffic, the LNER constructed Whitemoor Marshalling Yard in 1929. The yard covered 250 acres (101 ha) and had 42 sorting sidings, which were operated under the 'hump' principle. Coal trains from the south Yorkshire coal field that had travelled over the GN/GE line on a journey in the GNR book would be re-marshalled at Whitemoor to be distributed all over East Anglia.

This yard declined as wagon-load freight declined and disappeared altogether. Some of the site was eventually used for Her Majesty's Prison Whitemoor. There was a large locomotive power depot at Whitemoor, coded 31B under British Railways. The yard has

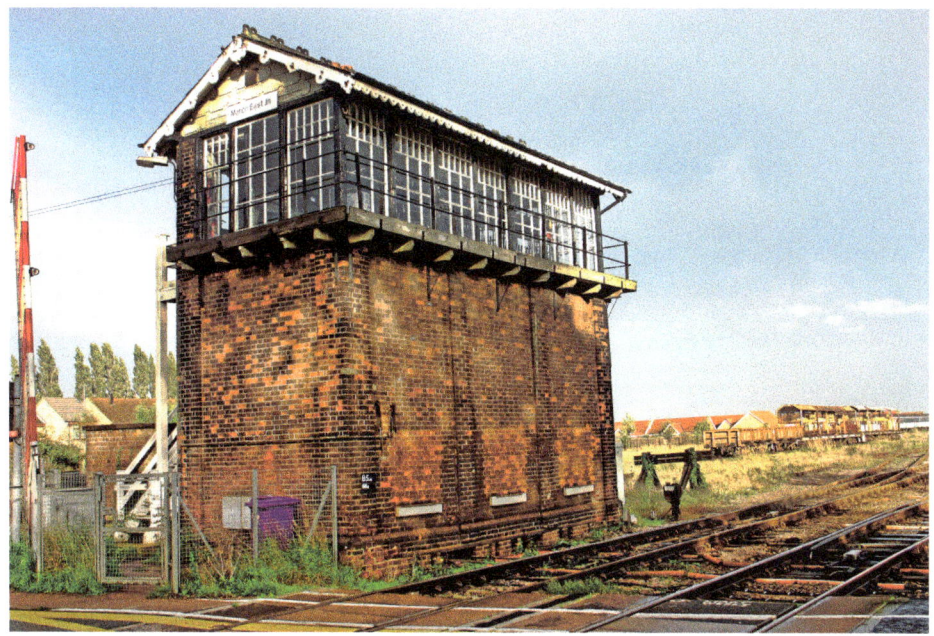

Fig. 13. March East Junction signal box. The box was raised in height in 1897 and it is possible to see the original brickwork line at about the height of the bricked up locking frame room windows. The lever count has been reduced over the years. (October 2006)

Fig. 14. The view from March station footbridge as Central Trains Turbostar, class 170, 170516 departs towards Ely. There are still some sidings at March; the Up yard is in view, although the Whitemoor yard junction is behind the camera. The Up yard had wagons and coaches stabled there at the earlier survey date. The next signal box at March South Junction is round the curve and out of sight in this shot. (October 2006)

made something of a comeback in recent years as it is a depot for permanent way and infrastructure trains.

March East Junction signal box is not far from March station and it now controls the Whitemoor yard junction lines, as well as the station and some sidings nearby.

March East Junction signal box is 85 miles and 69 chains (138.18 km) from Liverpool Street station via Ely.

Fig. 15. This is the view from the footbridge of March station. The station is a massive and substantial Victorian statement of worth and value, although the right-hand-side has lain dormant since the cutbacks of the 1960s. At the survey date there was a window etched with the legend '1st Class General Waiting Room'. Noteworthy is the saw-tooth platform canopy. At the end of the Up platform on the right can be seen a junction point and this leads to Whitemoor Yard. It is the exit road so is uni-directionally signalled from the yard past the platform, although the platform itself is bi-directionally signalled. Class 170, 170 272 departs for Peterborough past the platform starter at caution. (April 2015)

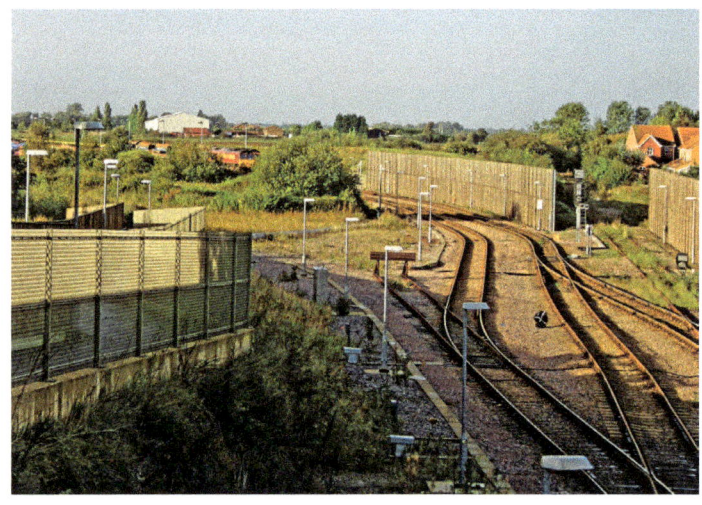

Fig. 16. Is an overview of the revamped Whitemoor Yard with a pair of unidentified class 66 locomotives in attendance. The line on the right is the Wisbech branch. (October 2006)

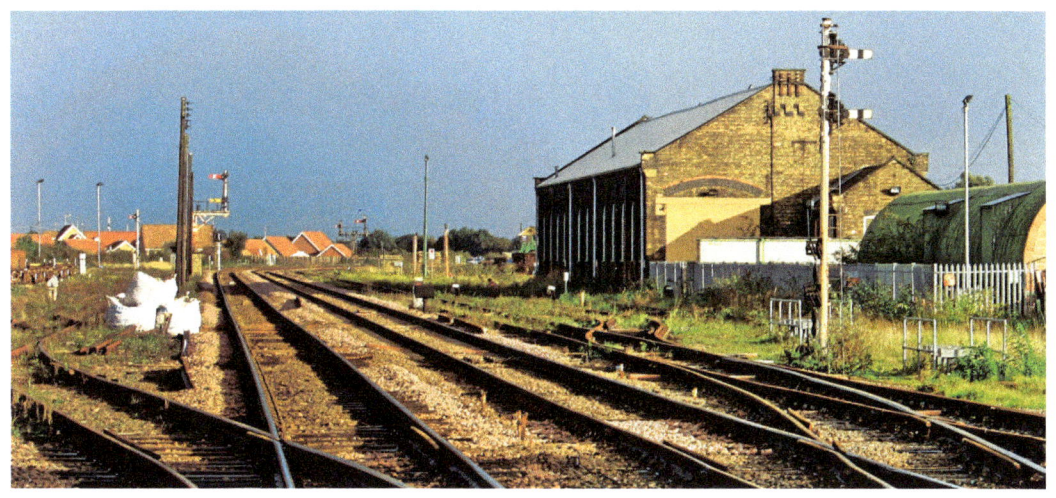

Fig. 17. This picture is across the crossing towards Ely and towards March South Junction signal box, which can just be seen on the far right on the curve. The goods shed on the right must have been for freight local to March as opposed to Whitemoor Yard. There is still a group of sidings and loops that form the Down yard and the subsidiary armed signals control movements out of up and down yards. The distant signal is likely to be March South Junction's as the boxes are so close to one another. The signaller will not be able to pull off the distant until the home signal to which it relates is also pulled off, and that is the next main signal arm on the bracket along the line. Note that beneath the distant signal arm there is a colour light signal with the white cross on it. This symbol is to inform the train driver that the signal is not in use yet. (October 2006)

March South Junction (MS)

Date Built	Type or Builder	No. of Levers	Ways of Working	Current Status 2015	Listed Y/N
1927	LNER Type 11a.	51	TCB	Active	N

Fig. 18. March South signal box. The dark blue East Region BR enamelled sign informing us we are ½ mile (0.805 km) from March station is a 1950s icon of the nationalised era. (October 2006)

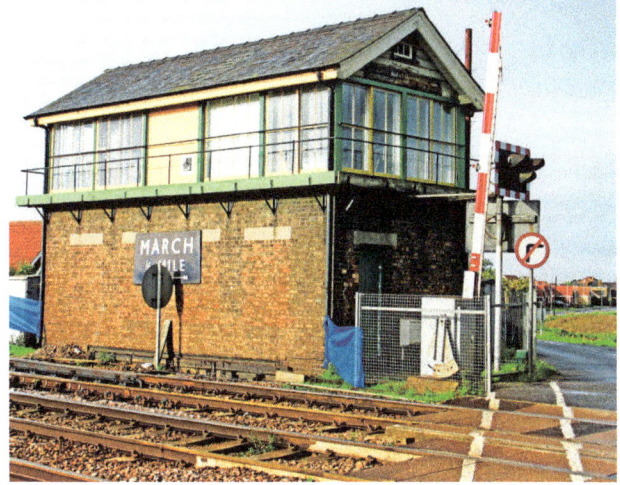

21

March South Junction has lost its nameplate, which is usually an ominous sign of impending doom, but not so at the survey date.

Above: Fig. 19. Around the curve to the left is March East Junction and this shot looks back from whence we had come in Fig. 17; the coaches in the Up sidings are on view and there is a ground disc to exit the loop that interfaces to the siding group. The smaller arm on the ex-LNER bracket signal is for the siding group too. (October 2006)

Left: Fig. 20. March South sidings signal. On the approach to March South Junction from Ely, the subsidiary armed signal has a stencil box beneath the arm to provide guidance to a train driver as to which of the four Down goods loops or sidings the train is to take. The view is almost from the river Nene. Noteworthy is that there are two ladders. Note also the GSM-R telephone number for March South Junction box and this is to enable the train driver to telephone the signaller if stopped at the signal. There is no MS plate on this signal. (April 2015)

March South Junction signal box is 85 miles and 35 chains (137.50 km) from Liverpool Street station via Ely.

Stonea (S)

Date Built	Type or Builder	No. of Levers	Ways of Working	Current Status 2015	Listed Y/N
1984	BR Portakabin.	IFS Panel	TCB,AB	Active	N

Stonea village is the site of an Iron Age fort.

The manual level crossing gates are not the only reason for being, as Stonea signal box is a block post passing trains as well.

Stonea signal box is 82 miles and 4 chains (132.05 km) from Liverpool Street station via Ely.

Fig. 21. Stonea signal box. Designed from the Portakabin school of architecture, unsurprisingly Historic England do not see this as a building of architectural merit. There are no mechanical signals here. (October 2006)

Manea (M)

Date Built	Type or Builder	No. of Levers	Ways of Working	Current Status 2015	Listed Y/N
1883	GE Type 3 & McKenzie & Holland.	25	AB,TCB	Active	N

Manea is an ancient but expanding village in the depths of the Cambridgeshire fenland. Manea signal box is 80 miles and 13 chains (129.01 km) from Liverpool Street station via Ely.

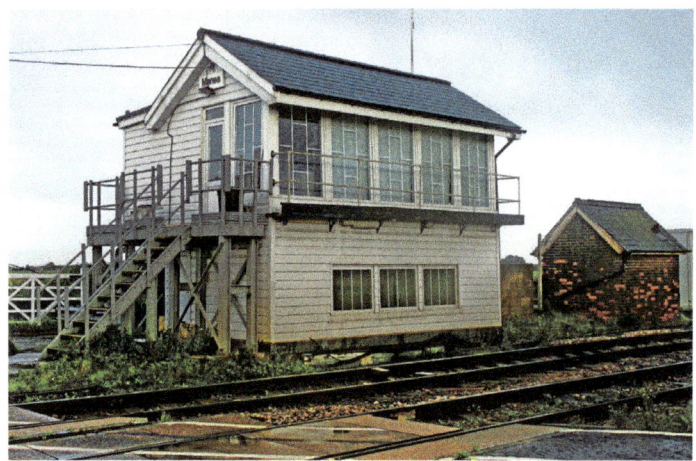

Fig. 22. Manea signal box has been completely enveloped in uPVC plasticised covering, but somehow the box retains its early and mixed parentage features. The lamp hut on the right is just as old but has not been interfered with. (October 2006)

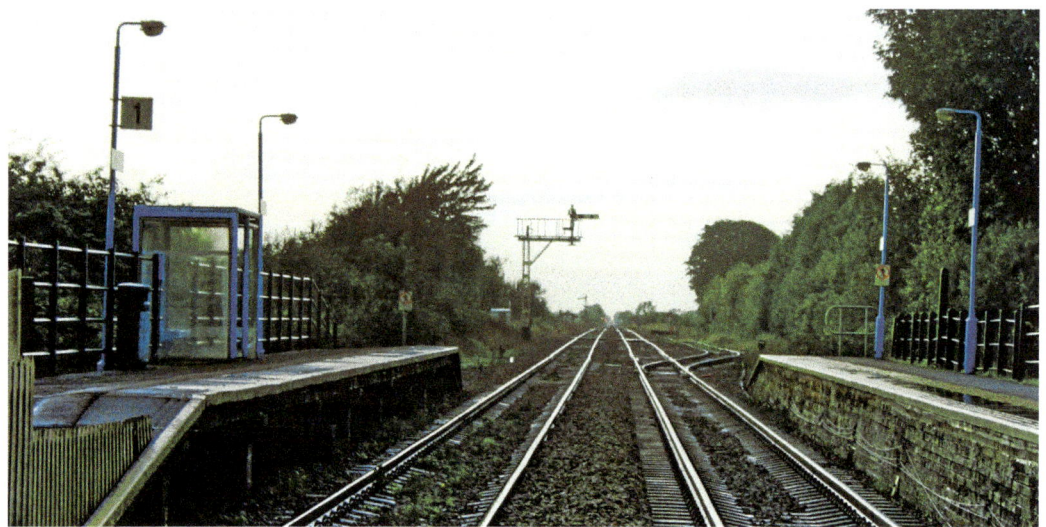

Fig. 23. Manea station owes much to minimalism, but the platform faces have age to them. The view is towards March and the Up side has the refuge siding. The angled-out bracket signal for the Up side must be a sighting issue. (October 2006)

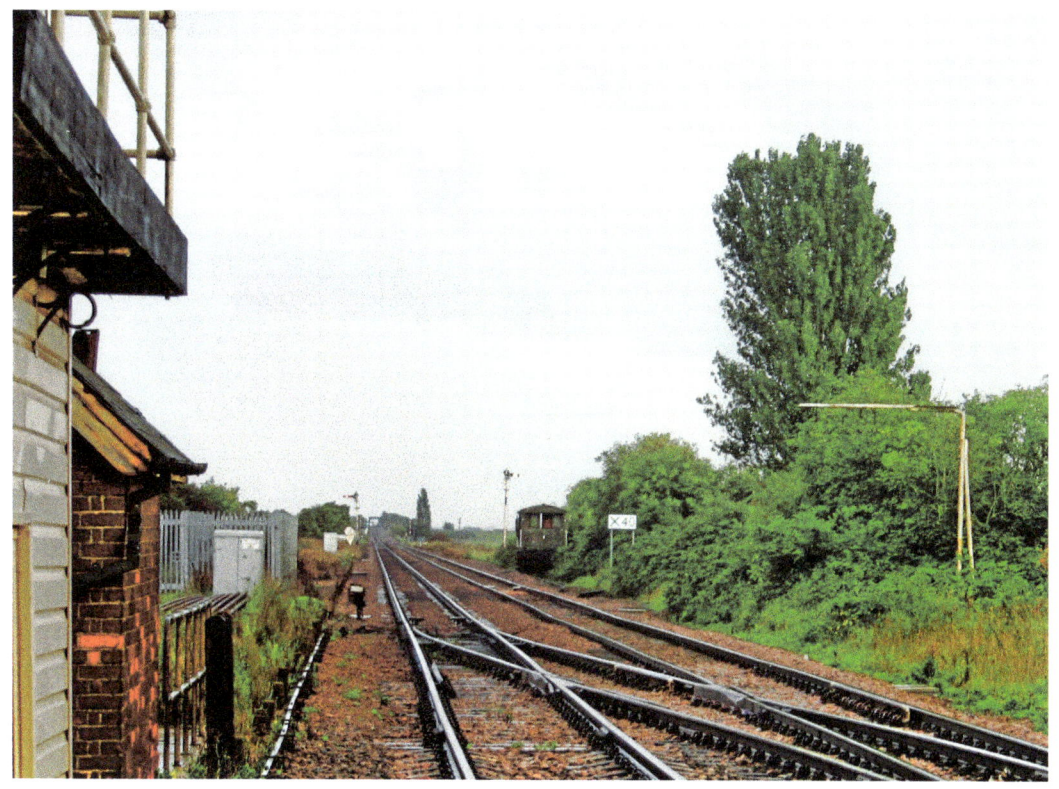

Fig. 24. The view is towards Ely with a goods yard loading gauge frame on the right. Also on the right is the remains of the Down refuge siding with a steam-age brake van on it. The X40 sign is a Network Rail standard sign to advise drivers that they must be doing 40 mph (64.4 km/h) or less by the time they reach the crossing that is coming up. Welney Road Crossing is 23 chains (463 m) from the box. (October 2006)

The journey now visits Ely, where it reverses to go up the electrified King's Lynn branch.

Litttleport (L)

Date Built	Type or Builder	No. of Levers	Ways of Working	Current Status 2015	Listed Y/N
1882	GE Type 2	25	TCB	Active	N

Littleport was the birthplace of locomotive crewman James Nightall who was posthumously awarded the George Cross for his part in trying to avoid the Soham rail disaster on the LNER in 1944.

The line from Ely is worked Track Circuit Block, even over the single lines, and so there is very little mechanical signalling from here to King's Lynn. The box had old-style wooden crossing gates at the survey date and the concrete post.

Littleport signal box is 76 miles and 2 chains (122.35 km) from Liverpool Street station via Ely.

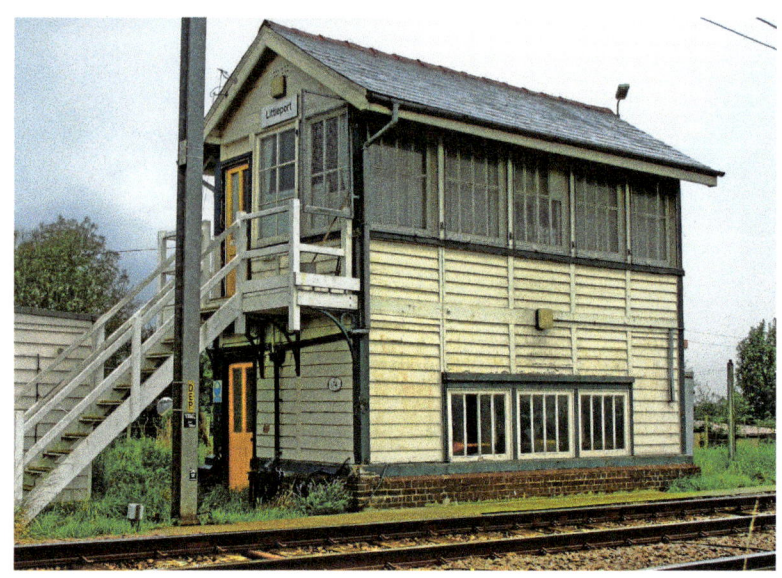

Fig. 25. Littleport signal box and one of the wicket gates is visible. Apart from the 25kV mesh grills on the windows the box is remarkably original and complete, although the wooden staircase is clearly a later replacement. (October 2006)

Downham Market (DM)

Date Built	Type or Builder	No. of Levers	Ways of Working	Current Status 2015	Listed Y/N
1881	GE Type 2	31	TCB	Active	Y 2013

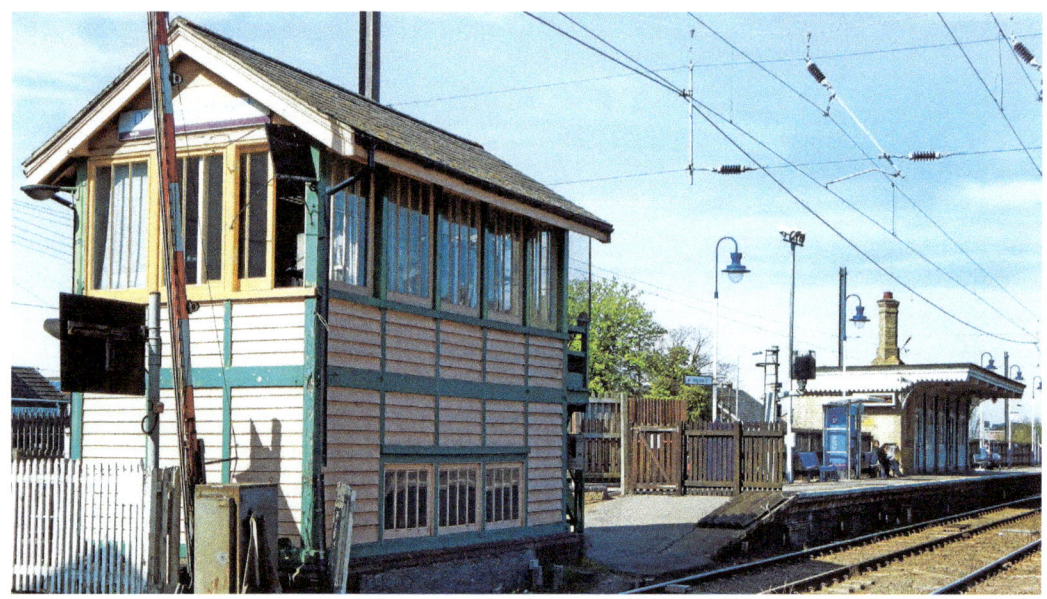

Fig 26. Downham Market signal box. The signal box looks to be of the same qualities as the station and clearly Historic England thought so too with its recent listing. (April 2015)

Fig. 27. Downham Market station and the view is looking towards King's Lynn and a reversion to double track. The couple of ground discs are just about the only mechanical signalling on this line. The yellow box between the rails in the foreground is an Automatic Warning System (AWS) inductor ramp; basically this system provides a warning as to the status of a distant signal and, if a signal is passed at caution and not acknowledged, the train's brakes are automatically applied. (April 2015)

In to the county of Norfolk, Downham Market is a pretty market town with royal connections to the civil war. The agricultural connections are strong and there were malting's in the town.

The station buildings are of rare quality and character. The station also has a small collection of platform seats – some Great Eastern.

Downham Market signal box is 86 miles and 4 chains (138.48 km) from Liverpool Street station via Ely.

Magdalen Road (MR)

Date Built	Type or Builder	No. of Levers	Ways of Working	Current Status 2015	Listed Y/N
1927	Great Central Type 5	IFS Panel	TCB	Active	N

The station started off life as Watlington and, presumably to prevent confusion with the GWR station of the same name, changed its name to Magdalen Road in 1875. The station was re-named Watlington in 1989, long after the GWR station had closed. The signal box retains the 1875 name, although it is much later and of Great Central Railway origin. The double track from Downham Market ends here and it is single to King's Lynn.

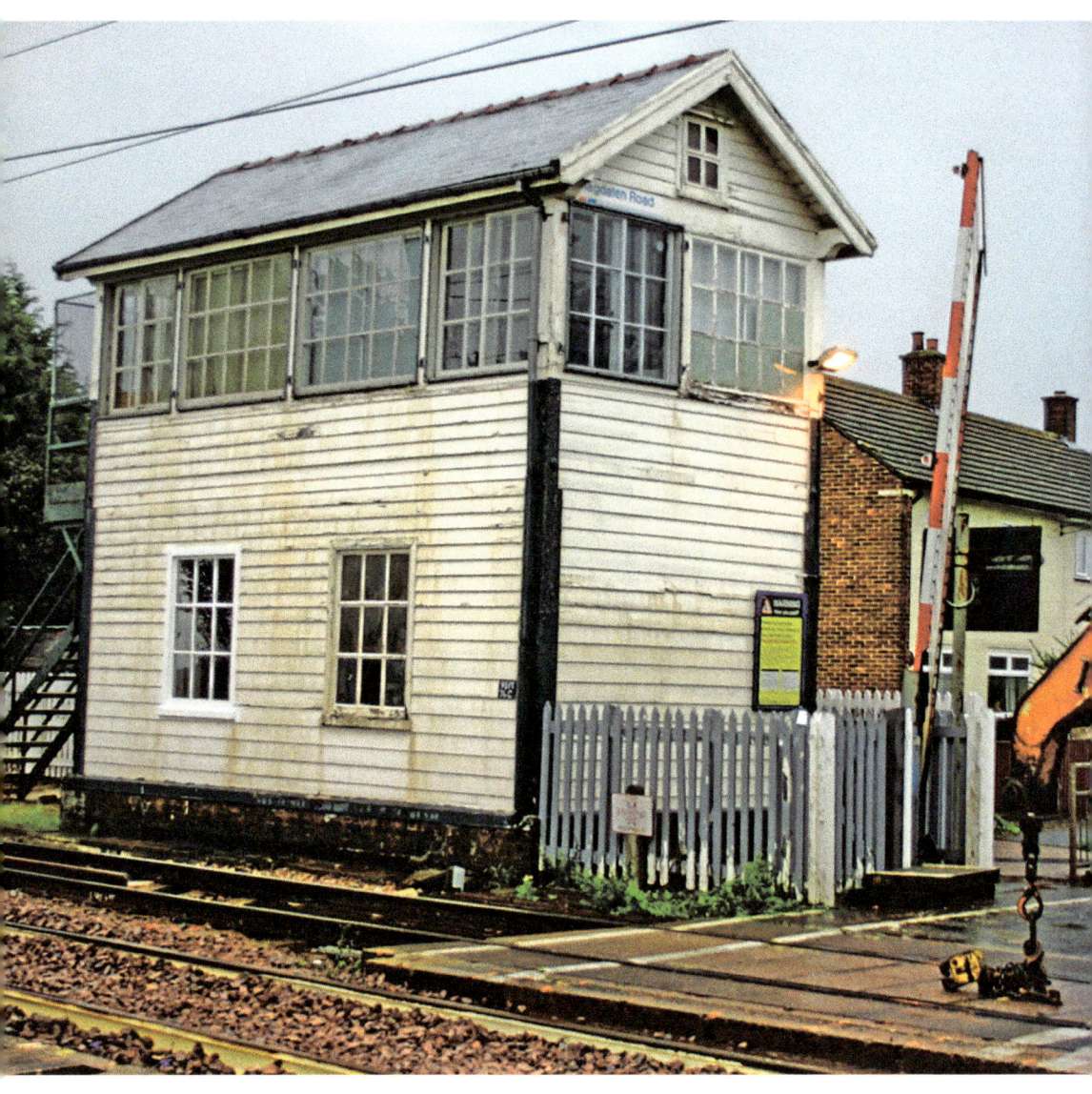

Fig 28. Magdalen Road signal box. The LNER presumably had these in kit form ready to wheel out and there was no such Great Eastern equivalent in 1927 when this box was needed. The crossing is being taken up in this 2006 view to have work done. (October 2006)

Magdalen Road signal box is 90 miles and 70 chains (146.25 km) from Liverpool Street station via Ely.

King's Lynn Junction (KL)

Date Built	Type or Builder	No. of Levers	Ways of Working	Current Status 2015	Listed Y/N
circa 1880	GE Type 2	49	TCB, OTS	Active	N

King's Lynn too had royal connections and was a considerable sea port, as well as a market town. There is a single track branch line to Middleton Towers – a fourteenth century listed fortified manor house – but the connection is freight-only to the sand pits. The line had been part of a branch line from King's Lynn to Swaffham. This line throws up some semaphore signalling.

The branch works OTS or One Train Working with Staff. This system, dating from the 1850s, relies on the train driver going down the branch to be in possession of a wooden staff with the branch section details engraved on a brass plate attached. Attached to one end of the staff is an Annett's key, which is a metal key to unlock ground frames for points on the branch. The staff, therefore, is a symbol of authority for the branch line without which the driver may not proceed and a practical device to unlock points, which will be required for the class 66 to run round its train. Once the staff has been issued the signals are locked at danger and no further train can proceed down the branch.

King's Lynn station is 96 miles and 75 chains (156.01 km) from Liverpool Street station via Ely.

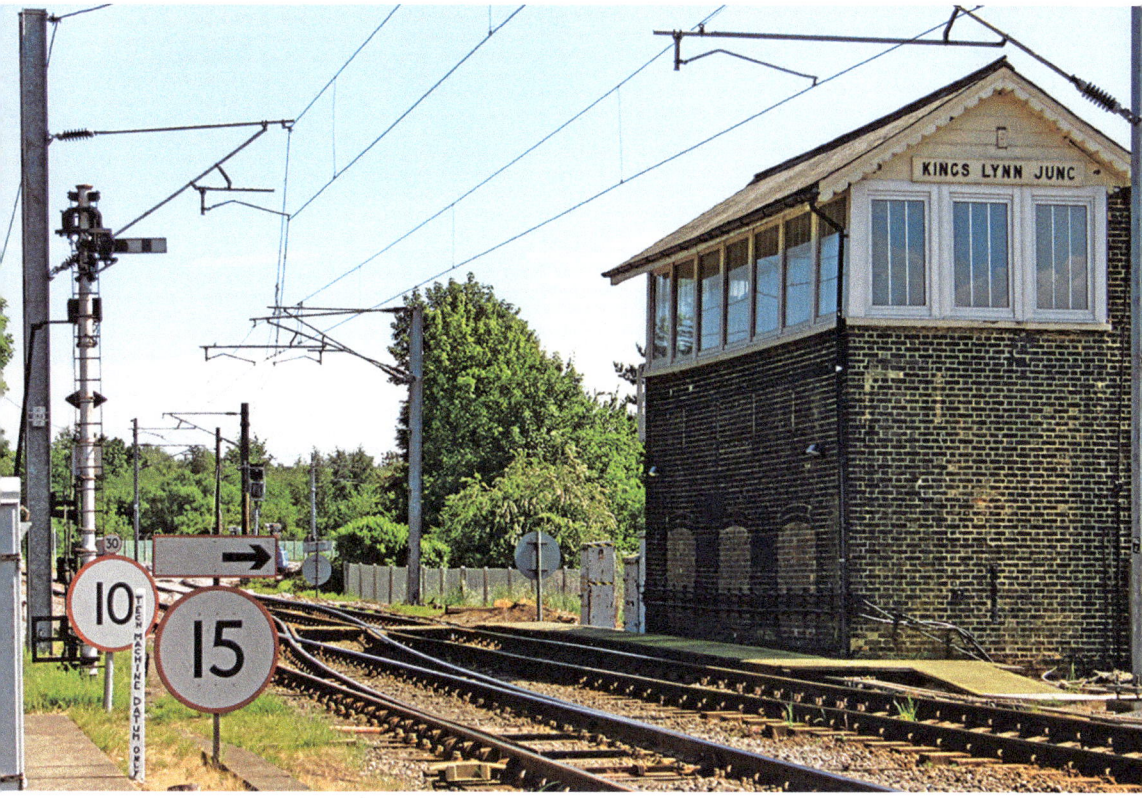

Fig 29. shows King's Lynn Junction signal box as heavily plasticised, bricked-up, and generally messed about with, but this is one of these purely functional buildings rather than a candidate for listing. The line to Middleton Towers goes off to the left and the semaphore signal is to signal a train off the branch. There is a black stencil box below the arm and that signals a choice of lines that a train coming off the branch can take inside the extensive freight and port siding complex. Freight trains coming off the branch have to run round here to ensure the locomotive is at the head of the train. The main line view is towards Magdalen Road and Ely. (May 2007)

29

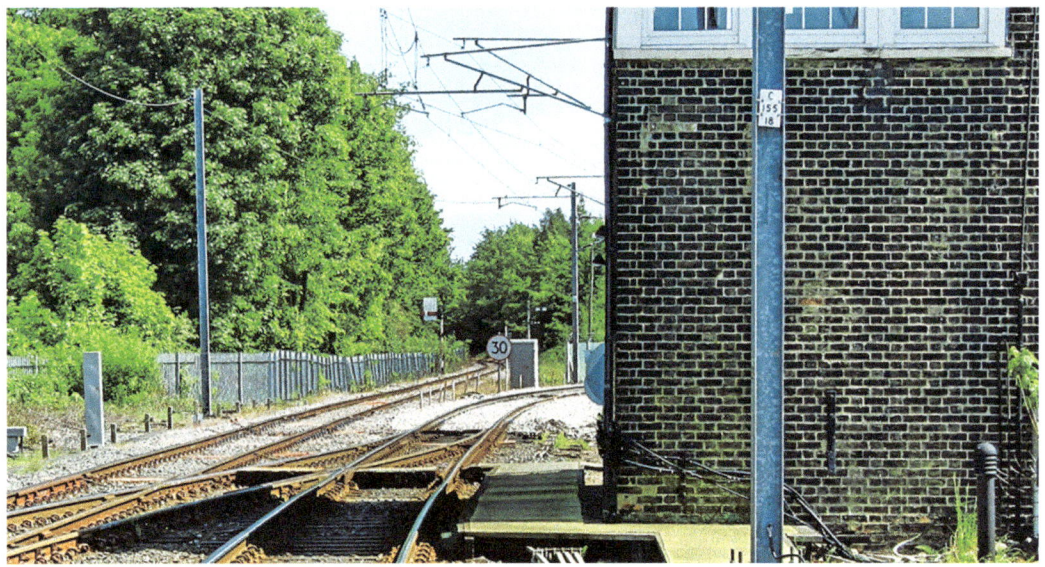

Fig. 30. King's Lynn Junction signal box and Middleton Towers branch connection. The branch starter signal complete with sighting board is in this view with the single track main line to Ely curving away to the right. The branch is used by class 66 locomotives with sand hopper wagons. The exit signal and subsidiary arm for the yard is also on view. (May 2007)

Fig 31. Journey's end and King's Lynn station in the middle of the day is not a hive of activity as with so many commuter stations. Only platforms 1 and 2 on the right were in use at the survey date. (June 2006)

Ely to Yarmouth Vauxhall

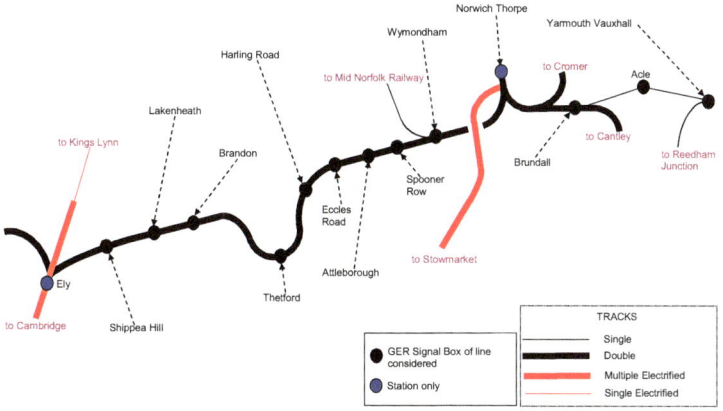

Ely to Yarmouth Vauxhall.

The fen crossing starts in earnest and proceeds towards Thetford forest, but not before entering Suffolk briefly at Brandon.

Wymondham is a delightful station and where the preserved Mid-Norfolk Railway branches off. Then the line runs into Norwich. Norwich is a centre for agriculture and administration for Norfolk and is the county town. The spire of the cathedral is another of those fenland beacons, like Ely, which can be seen for miles around.

After Norwich is Brundall – the scene of an early signalling disaster – and, after the charming village of Acle, the sea is reached at Great Yarmouth. Norwich and Yarmouth stations are qualified by their old names and this simply serves to highlight that there was an interloper in Norfolk in the shape of the Midland and Great Northern Railway, who had stations at both Norwich and Yarmouth, and whose spirit lives on in the shape of the North Norfolk Railway or Poppy Line at Sheringham.

The not-to-scale schematic diagram at Fig. 32 illustrates the route and connections.

Shippea Hill (SH)

Date Built	Type or Builder	No. of Levers	Ways of Working	Current Status 2015	Listed Y/N
1883	GE Type 4 & MacKenzie and Holland	25	AB	Demolished	N

Shippea Hill station holds the dubious distinction of being one of the least patronised stations on Network Rail. One year recorded eleven passenger journeys.

Shippea Hill signal box was 77 miles and 26 chains (124.44 km) from Liverpool Street station via Cambridge.

31

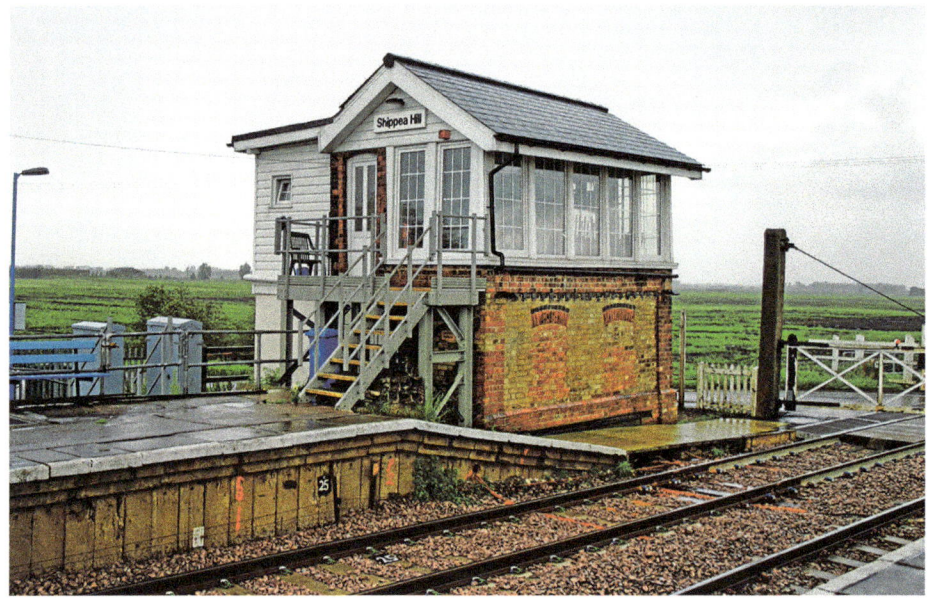

Fig. 33 Shippea Hill signal box and the gates next to the box provided a reason for the box to be, until barriers were fitted in 2011. An appeal to local people to undertake its care and maintenance fell on few or no ears as this is one of the least populated areas of the county. (October 2006)

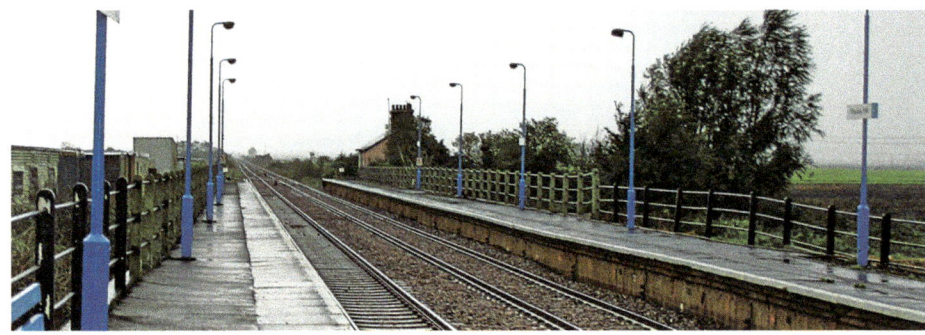

Fig. 34. Another exercise in minimalism with not even waiting shelters for passengers for the one train a day. No doubt this is a 'Parly' or parliamentary train that has to run as part of the obligations to provide a service under the original act of 1845. The only mechanical signals discernible here was the pair of ground discs for the crossover and the crossover has subsequently been removed. (October 2006)

Lakenheath (L)

Date Built	Type or Builder	No. of Levers	Ways of Working	Current Status 2015	Listed Y/N
1883	GE Type 4 & Saxby and Farmer	25	AB	Closed	N

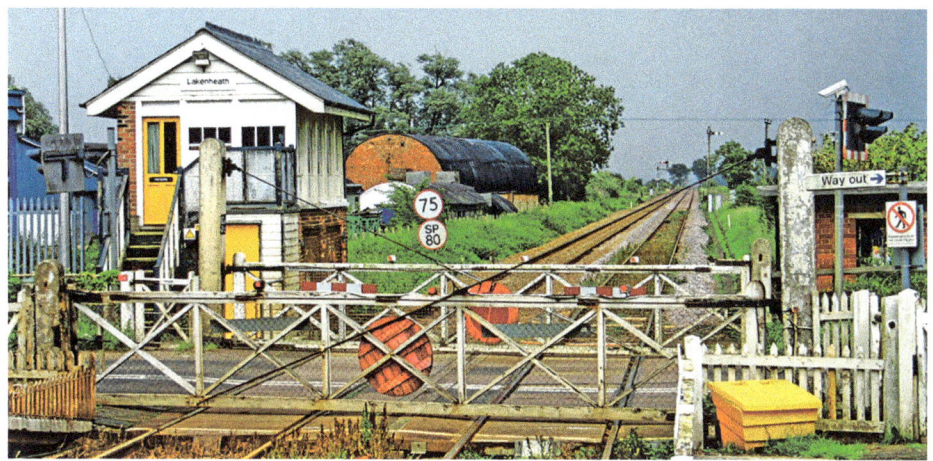

Fig. 35. Lakenheath signal box has the by now familiar manual gates with all sorts of warning lights and circular 'targets', which motorists are supposed to miss. The speed restriction roundel advises drivers that 'Sprinter' trains can go 5 mph (8.05 km) faster than anything else. (October 2006)

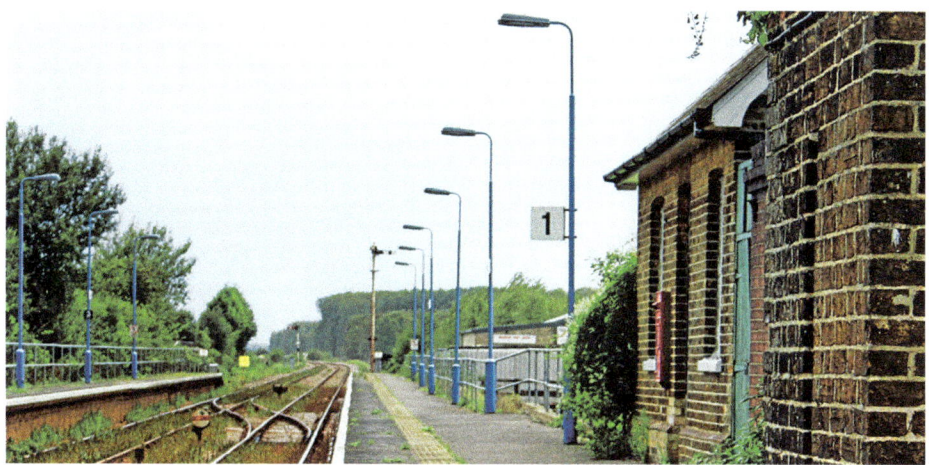

Fig 36. The view towards Ely and note how narrow the Down left-hand platform is. The station building, although closed, still serves as a post-box and isolated communities often relied on the railway for such services. The trailing crossover is track circuited, so perhaps there was a requirement to reverse passenger trains over the crossover. (October 2006)

Lakenheath has vied with Shippea Hill for top unpopularity with passengers, but has seen numbers soar to 440 a year after the introduction of weekend services for the RSPB sanctuary nearby.

Lakenheath station buildings have survived on the Up side in the Ely direction, although is now closed up and not seemingly in use at the survey date.

Lakenheath signal box is 82 miles and 49 chains (132.95 km) from Liverpool Street station via Cambridge.

Brandon (B)

Date Built	Type or Builder	No. of Levers	Ways of Working	Current Status 2015	Listed Y/N
1931	LNER Type 11a.	40	AB	Closed	N

There is now a brief foray into Suffolk and Brandon. The town saw an early influx of Polish people who had fought for Britain in the Second World War, and these were supplemented later by families from the nearby USAF Lakenheath.

The station also had active freight services with a small EWS yard on the Down side towards Norwich and refuge sidings on the Up towards Ely.

Brandon signal box is 86 miles and 25 chains (138.91 km) from Liverpool Street station via Cambridge.

Brandon signal box at Fig. 37 is after the style of March South Junction and roughly the same period of early LNER ownership. The slate roof betrays the place where the stove was removed and the box seems quite large for just a forty lever frame. An example of LNER cross-use of equipment is the fact that the lever frame is ex-Great Northern Railway. (June 2006)

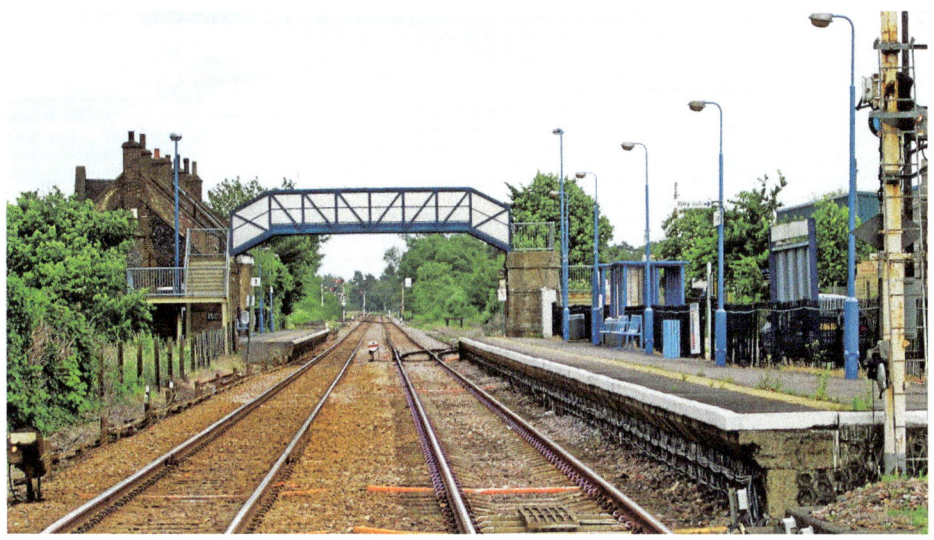

Fig. 38. The station at Brandon and most of the signalling is in view in this shot. Reading from left to right it is:
1. Ground disc from crossover, which is behind the camera.
2. Past the station building and Down platform towards Norwich is a couple of siding exit signals on the same post.
3. Next is the bracket for a train to enter the Up goods loop and sidings.
4. After the bracket signal along the line is a home section signal.
5. A ground disc for reversing into the Up refuge sidings; not track circuited.
6. A home section signal protecting the Up refuge sidings, complete with sighting board.
7. Finally, on the extreme right the platform, starter signal for the Up line towards Ely. (June 2006)

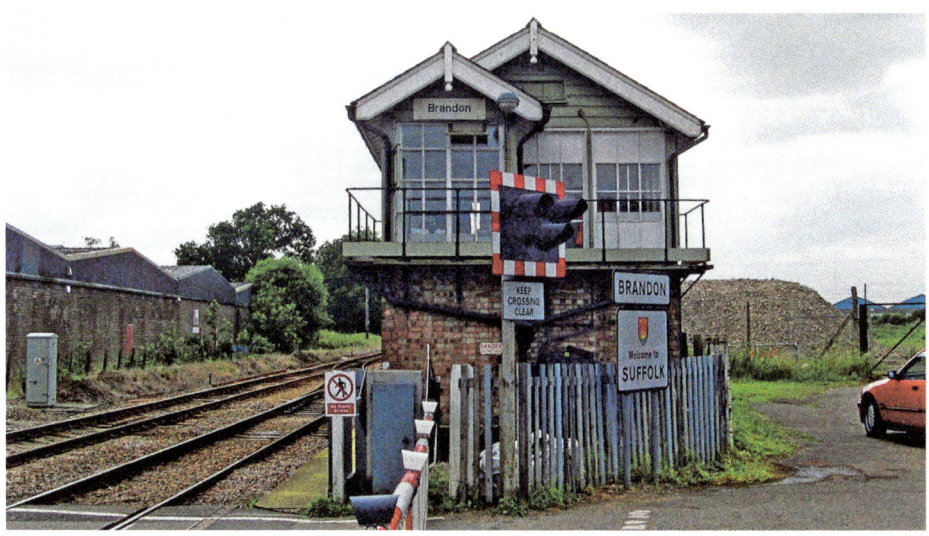

Fig. 39. This view shows the crossover for the disc signal referred to in (1) on the previous figure. The porch is built on the opposite end to the staircase and it is possibly to do with an adequate lookout for the road traffic. (June 2006)

Thetford (T)

Date Built	Type or Builder	No. of Levers	Ways of Working	Current Status 2015	Listed Y/N
1883	GE Type 4 & MacKenzie and Holland	33	AB	Closed	Y 2013

The town is an important crossroads and was a railway junction for the line to Bury St. Edmunds, but this closed in the 1950s. Thetford Forest is a delightful pastoral area much-used for leisure purposes and the filming of the TV series *Dad's Army*.

The station building and goods shed were both in good condition at the survey date and not much seems to have changed since the steam era. The knapped flint station building and its brick extension are Grade 2 listed.

Thetford signal box is 93 miles and 44 chains (150.55 km) from Liverpool Street station via Cambridge.

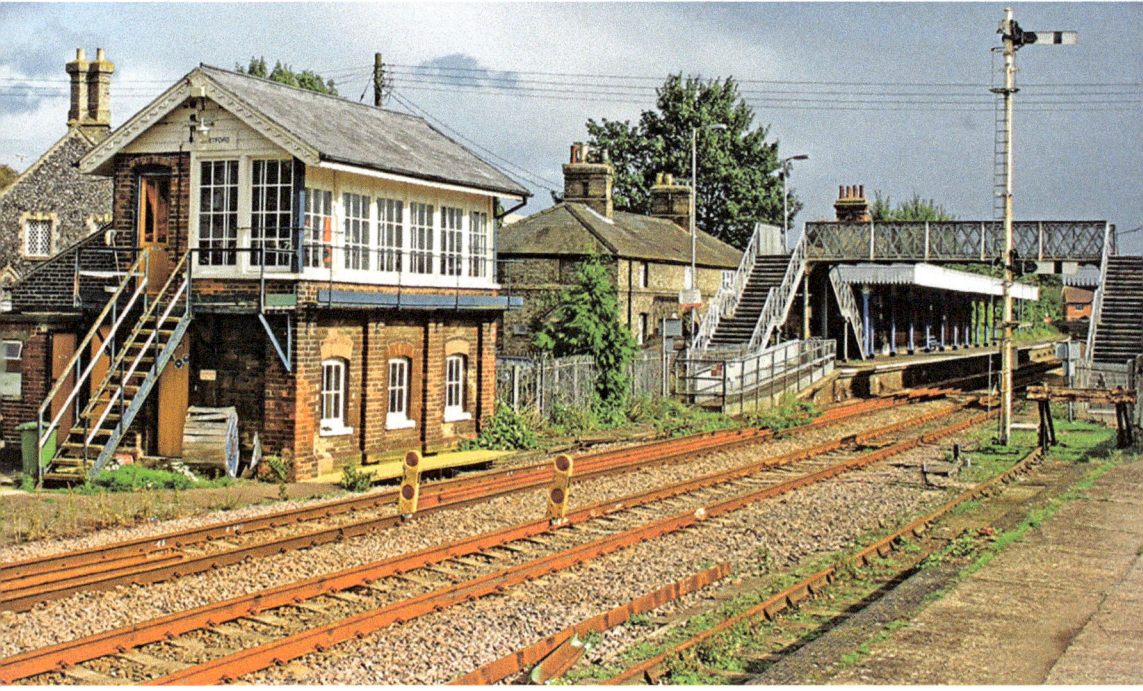

Fig. 40 and semaphore signals are thin on the ground just here, but the signal in the foreground is quite rare. It has co-acting arms – that is to say the signaller pulls one lever in the box and both arms go up. When the lever is set back to normal, both arms go to danger. They are used where there is a sighting problem that cannot be solved by boards or position; in this case, the footbridge and canopy are the reasons. The knapped flint building behind the box would appear to the stationmaster's house. Both tracks have a Possession Limit Board (PLB), which identifies the limit of the line's possession by engineers. The siding in the foreground is for the goods loading dock and the goods shed is behind the camera. (October 2006)

Fig. 41 is the view towards Ely and another relic from a bygone age. The goods loading gauge seems to be fully functional and there is a winding handle on the post that lifts the gauge outer sections upwards. The lamp platform for the lower co-acting signal is on the right. (October 2006)

Fig. 42. This is also towards Ely but amply demonstrates the working of the co-acting signal arm. From this position the train driver relies on the lower arm and, beyond the canopy and further back from behind the camera, the upper arm is in view. (October 2006)

37

Fig. 43. The goods shed looks recently used but would seem to be in other use, judging by the alarm bell box. The offices are round the side to the right. (October 2006)

Harling Road (HR)

Date Built	Type or Builder	No. of Levers	Ways of Working	Current Status 2015	Listed Y/N
1883	GE Type 4 & MacKenzie and Holland	25	AB	Closed	N

Harling Road station is isolated and the clue to this is in the use of the term 'Road' in the title. This was the railway company's way of informing travellers that the station was some way off from the community it served.

Harling Road signal box is resting in rural contemplation, Fig. 44, and framed by the almost-inevitable wooden manually closed gates. (June 2006)

38

Fig. 45. Harling Road station retains the original building on the Down side on Platform 2 towards Ely. Worthy of note is the narrowness of the Up Platform 1 on the other side of the tracks. With staggered and narrow platforms the Great Eastern was careful not to take too much land when building the railway. (June 2006)

Harling Road station is 101 miles and 35 chains (163.25 km) from Liverpool Street station via Cambridge.

Eccles Road (ER)

Date Built	Type or Builder	No. of Levers	Ways of Working	Current Status 2015	Listed Y/N
1883	GE Type 4 & MacKenzie and Holland	21	AB	Closed	N

Eccles Road signal box is very similar to Harling Road, but the gates are quite different. At Eccles Road the gates do not cover the aperture of the railway tracks as the road is a narrow lane.

Eccles Road station is 104 miles and 39 chains (168.16 km) from Liverpool Street station via Cambridge.

39

Eccles Road signal box. Note the crossing gate post by the box no longer in use, figure 46. (June 2006)

Fig. 47. A view of the LNER signal lamp on top of the crossing gates at Eccles Road. When the gate is closed to the road the lamp shines towards the road. This lamp was originally an oil lamp and isolated communities such as this were probably not connected to mains electricity until after the 1960s. Note the signal off for an approaching train. (June 2006)

Fig. 48 illustrates the shortcomings in the gates already referred to where the gate is secured by a bolt onto the track. The trailing crossover is on view as is, just, the point to a disused grain loading terminal. (June 2006)

Attleborough (A)

Date Built	Type or Builder	No. of Levers	Ways of Working	Current Status 2015	Listed Y/N
1883	GE Type 4 & MacKenzie and Holland	36	AB	Closed	Y

Attleborough is a delightful market town that precedes London in the conflagration stakes, in that it had its own great fire more than 100 years before the capital.

The station buildings remain and a ticket office has been re-opened, exactly forty-one years after it was closed.

Attleborough station is 108 miles and 19 chains (174.17 km) from Liverpool Street station via Cambridge.

Fig. 49. Attleborough signal box is also a delightful structure bedecked with flowers and greenery. The signaller here, one freezing January morning in 2011, advised the waiting passengers from the PA system that, as their train was 25 minutes late, would they care to join him for a cup of tea in the signal box? They did. Although the box is listed and remains, the signaller is gone. (June 2006)

Fig. 50. In the view towards Norwich, Attleborough station's Platform 2 still has its canopied shelter in operation. The trailing crossover is the only point containing track component here. Attleborough is another station with staggered platforms and the wooden gates dividing them. Note that although there is just a crossover, serviced by the single rod on the bottom right of the picture, there had been quite a few rodded points here as the vacant carriers or stools with their pulley wheels testify. (June 2006)

Fig. 51 and Attleborough station is obviously well cared for, probably by volunteers, with platform seats, litter in the bins, hanging baskets, and a neat and tidy appearance. The goods shed is another survivor on the right. Underneath the canopy is a war memorial dedicated to the United States Air Force and their sacrifices in the Second World War. (June 2006)

Spooner Row (SP)

Date Built	Type or Builder	No. of Levers	Ways of Working	Current Status 2015	Listed Y/N
1881	GE Type 2	15	AB	Closed and Moved	N

Spooner Row signal box.
(June 2006)

Spooner Row is a station where the buildings have not survived, but this time due to a disastrous fire in the 1970s. The signal box, however, has been luckier and has a new home at Wymondham Abbey on the Mid-Norfolk preserved railway a few miles away.

Fig. 53 depicts Platform 1 of Spooner Row station looking towards Ely. The cottages look like former railway cottages. (June 2006)

Fig. 54 and another survivor from yesteryear is the pole route of analogue telephone wire poles. These routes were originally to carry railway communications of telegraph, block apparatus and, latterly, telephones. They were subsequently used for the national GPO telephone network before it went digital. (June 2006)

Spooner Row station is 111 miles and 27 chains (178.91 km) from Liverpool Street station via Cambridge.

Wymondham (W)

Date Built	Type or Builder	No. of Levers	Ways of Working	Current Status 2015	Listed Y/N
1877	GE Type 2	42	AB	Closed	Y

Wymondham – locally pronounced 'Windum' – is a pretty market town and is the junction for the now preserved Mid Norfolk Railway to Dereham.

Wymondham station is 113 miles and 69 chains (183.24 km) from Liverpool Street station via Cambridge.

Fig. 55 and the signal box has retained its original name of Wymondham South Junction. The junction with the Mid Norfolk Railway is on the right. The line on the left is a loop line round the back of Platform 2 of the station, which is behind the camera. The sidings on the right past the box have a crossover at the end that would enable a train that has come off the branch to run round, so as to be facing the correct way before setting off down the main line. There are three sets of double railed trap points on this view towards Spooner Row and Ely. (October 2006)

45

Fig. 56 is the view towards Norwich and of the splendidly preserved station buildings here. The goods shed survives in good condition and is behind the station, and the café on Platform 1 was doing brisk business at the survey date. The bracket signal is for the Down line towards Ely and note the anti-climb panel on the ladder. (October 2006)

Fig. 57 is looking towards Ely again but this time from Platform 1. The sign at the end of Platform 2 is to warn drivers that they are entering a low adhesion area of the track. The sign is meant to be a leaf, which cause traction problems in the autumn. (October 2006)

Brundall (BL)

Date Built	Type or Builder	No. of Levers	Ways of Working	Current Status 2015	Listed Y/N
1883	GE Type 3 & Stevens & Co.	35	AB,TB	Active	Y

Fig. 58 and the recently listed box is distinctive in having terracotta cockscomb ridge tiles and roof finials. The window configuration is most unusual with the horizontal bars at differing heights. The box works Absolute Block to Reedham Junction and single line Tokenless Block (TB) to Acle. (April 2015)

Brundall is a village on the banks for the river Yare and this is fitting as our eventual destination is the mouth of the river at Great Yarmouth. Brundall station is the junction for the double track line to Reedham Junction for Lowestoft and points south and the single track to Acle and Great Yarmouth.

Tokenless Block Operation

This method of operation was invented in the 1960s to speed up operation of trains on single lines as it does not need to issue and collect from them physical tokens for each section.

The principles of Tokenless Block are:

Let us suppose that a train is to be passed from Brundall to Acle. The Tokenless Block instrument has three positions:

NORMAL –	Line blocked
RED –	Train in Section
GREEN –	Train Accepted

There is also an Offer button, Accept button, and Train Arrived button at both signal boxes.

To pass the train from Brundall to Acle, the signaller at Brundall presses the Offer button and, if Acle selects Accept, this is reflected on Brundall's TB instrument as Train Accepted. This then locks all the signals on the single line from Acle to Brundall at danger. In other words, a train cannot pass in the opposite direction to which this train is going, unless it passes several signals at danger.

When the train has arrived in the section at Brundall, the track circuits sense this and turn both block instruments at Brundall and Acle to Train in Section.

When the train has arrived at Acle, complete with tail lamp, the signaller at Acle selects Train Arrived and the instruments revert to Normal. This operation is interlocked with any relevant points on the route.

Brundall station is 5 miles 62 chains (9.29 km) from Norwich Thorpe station.

Fig. 59 is a shot of the junction and the line to Acle curves around to the left and becomes single track within a short distance. The double tracks to Reedham Junction and Lowestoft curve away to the right. The line is set for a train to Lowestoft. (April 2015)

Fig. 60 and Abellio Trains class 156, 156409 pulls into the Down platform at Brundall past two semaphore signals, but this train is going to Great Yarmouth via Acle so will take the left-hand curve of the previous figure. (April 2015)

Fig. 61 and class 156, 156409 is returning from Great Yarmouth from the Reedham Junction direction with all other signals at danger. (April 2015)

Fig. 62 and a cheery Canadian operates the crossing gates at Brundall. This guy had been a signaller at Spooner Row and came to Brundall after his box closed. (April 2015)

Fig. 63 is an earlier view of Brundall station and the crossing keeper's hut is the brick-built building by the footbridge with the white painted gable ends. There is an electric bell and the signaller gives three rings from the signal box to advise that a train is coming. The crossing keeper then nips out and places both sets of gates across the road and locks them in position. Only then, when the gates are locked in position, can the signaller in the box pull off for the train. (April 2015)

Acle (A)

Date Built	Type or Builder	No. of Levers	Ways of Working	Current Status 2015	Listed Y/N
1883	GE Type 3 & Saxby & Farmer.	20	TB	Active	N

Acle is a delightful village and the station exists in a kind of time warp, with only the goods shed not in some sort of railway service. The station has won several awards in the 'best kept' genre. The layout here consists of two points that form the passing loop and platforms for each direction.

Acle station is 10 miles 34 chains (16.78 km) from Norwich Thorpe station.

Fig. 64 is the view towards Great Yarmouth with all the section home signals on display. Even the waiting room on the Norwich platform looks smart and well cared for, as evidenced by the yellow painted step. The short signal disease has not reached Acle yet. (April 2015)

Fig. 65 towards Norwich now and the period scene is almost complete, except for the LED fibre optic banner repeater signal on the Norwich-bound platform. This is entitled A3 BR, which means it is the Banner Repeater for Acle's number 3 signal, whose parent we shall see later. Banner repeaters are another solution for sighting problems. (April 2015)

Fig. 66 and the first signal along the track towards Norwich is A3, and the banner repeater shows the same aspect except in LED light diagrammatic form. The anti-climb panel on the ladder is a recent instruction as a rail worker recently (2015) fell off a signal at Cantley. (April 2015)

Fig. 67 and the box is unusually on the platform at Acle and hardly recognisable underneath all that plastic and plain window frames. (April 2015)

Fig. 68. Finally at Acle we are Norwich-bound and A3 is the signal right in front, with the two other home signals behind it. Note from the width of the bridge that the line was originally double track. (April 2015)

Yarmouth Vauxhall (Y)

Date Built	Type or Builder	No. of Levers	Ways of Working	Current Status 2015	Listed Y/N
1884	GE Type 4 & Saxby & Farmer.	63	TB	Active	N

Great Yarmouth has been a seaside resort since the eighteenth century and was one of the premier fishing ports in Britain for herring. In common with most of the rest of Britain, fishing has been in decline and newer ventures to support offshore oil, gas, and renewable energy systems are in place.

The station was established in 1844 and had a large goods yard and lines to the docks, as well as a motive power depot in steam days coded 32D by British Railways. The station is odd in that it is served by two single lines – one from Acle, the other also from Norwich via Reedham Junction. Both lines work the Tokenless Block system.

Fig. 69 is looking at the loco release crossover on Platform 2 and the ground frame that controls it with the three levers and telephone on the post, which connects directly to the signal box in the far distance. Locomotive-hauled trains are still reasonably common and the instruction to operate the ground frame dates from 2011. (April 2015)

53

The ground frame edited operating procedure is as follows:

1. The train driver phones up the signaller and they decide what manoeuvre is to be carried out. We are assuming, in our example, it is to release a locomotive over the crossover. The train driver requests that the signaller release the ground frame lock from the box to enable the ground frame to be used.
2. The train driver then presses and holds the plunger, which is behind lever 1 and, at the same time, pulls brown lever 1 over. This is the ground frame locking lever and the ground frame is now unlocked. Check that the circular instrument behind lever 3 shows FREE.
3. Pull over blue lever 2, which is the facing point lock and this will enable the points to be moved.
4. Reverse black lever 3 to change the crossover points.
5. Replace lever 2 to normal to re-lock points in the new position.
6. Carry out manoeuvre with locomotive.
7. Pull over, reverse, lever 2 again and this frees the facing point lock.
8. Replace lever 3 to normal.
9. Replace lever 2 to re-lock points in the original position.
10. Press and hold the plunger which is behind lever 1 and, at the same time, replace lever 1 to normal.
11. Advise signaller that the manoeuvre is completed.
12. Check that the circular indicator indicates LOCKED.

Fig. 70 is the view of the platform ends at Yarmouth Vauxhall station and the four starter signals tell us there are four platforms. Each starter signal has a ground disc to signal a move to the carriage sidings, which are beyond the road overbridge on the right of the running lines. The theatre-style route indicator is necessary to inform the driver which route – either A for Acle or R for Reedham Junction – the train is to travel on. The Platform 2 train will be Reedham Junction-bound. Each signal on view is designated, from right to left, Y1, Y2, Y3, Y4, and these signal plate numbers align with the platform numbers. (April 2015)

Note that there is a treadle on the platform 2 rail to sense the presence of a train.

Yarmouth Vauxhall station is 18 miles 29 chains (29.55 km) from Norwich via Acle and 20 miles 46 chains (33.11 km) from Norwich via Reedham Junction.

Fig. 71 and Abellio class 156, 156407 gingerly heads for Reedham Junction on its way to Norwich from Platform 2 and past signal Y2. (April 2015)

Fig. 72 depicts Yarmouth Vauxhall signal box with ornate cast-iron brackets to support the walkway and bricked-up locking frame room windows. The latter would appear to be a war-time measure as Yarmouth was heavily bombed in the Second World War. An LNER concrete hut completes the scene. (April 2015)

55

Fig. 73 and the view is the station throat at Yarmouth Vauxhall. The four platform lines are directly in front of the box and the fifth on the right is a long carriage siding leading to a headshunt. This siding and beyond to the ASDA store on the right are the site of the goods yard and locomotive depot in steam days. Worthy of note is the mass of point rodding coming from the carriage sidings to the box and the way the walkway is bridged over the rodding. The line on the left next to the rodding is a direct connection to the carriage sidings from Platform 1. (April 2015)

Fig. 74 is the final photograph of Yarmouth Vauxhall's infrastructure and it is the carriage sidings exit signal, with a stencil box offering one of six selections of tracks to take. A telephone on a post is provided to talk to the signaller. The one signal is for all the carriage sidings. (April 2015)

Fig. 75 is from the other side of the road overbridge from whence Fig. 73 was taken. Starting at the top of the picture, the two red colour light signals confirm that there are two single track main running lines here instead of the more usual Up and Down to one direction.

The Abellio class 156, 156412 has just come from Acle on the single line and is about to pass the connection to the five carriage sidings, which are actually loops with a loco release headshunt. The right-hand track is trap pointed as it leads to Platform 1, where a train might be. This was the track nearest to the signal box in the previous figure. After that is a crossover to permit trains from Acle or the carriage sidings to access platforms 3 and 4 and the far siding. The far left-hand track is the headshunt for the ASDA siding; note that there is also some track even to the left of that, in the undergrowth.

The class 156 is heading for Platform 1, judging by the way the bottom point is set. (April 2015)

Cantley To Ipswich

The schematic not-to-scale diagram at Fig. 76 does not give a picture of the nature of this journey, but perhaps the names of the signal boxes might. Swing bridges indicate that the railway criss-crosses navigable waterways. The county of Suffolk is reached and, after a stop-over at Lowestoft, the railway heads south on the East Suffolk line before reaching the eventual destination of Suffolk's county town at Ipswich.

Cantley (C)

Date Built	Type or Builder	No. of Levers	Ways of Working	Current Status 2015	Listed Y/N
1887	GE Type 7	22	AB	Active	N

57

Fig. 76 Cantley to Ipswich.

Fig. 77 and the view is towards Norwich with the by now established Norfolk pattern of station, box, and manually-gated crossing. The Up refuge siding point and ground disc can just be seen with the sugar beet factory in the background. Note that the ladder for the home signal is mounted to the front by the platform ramp, as conventionally mounting it at the rear would expose the maintainer to a road hazard. (June 2006)

Cantley is a village dominated by the sugar factory, owned by British Sugar, where sugar beet grown locally is rendered into the sweet product.

Cantley station is 9 miles 79 chains (16.07 km) from Norwich Thorpe station.

Fig. 78 and some original station buildings in brick and timber at Cantley station and the concrete platform face opposite looks as though it was a later, possibly war-time addition. The original platforms are further away towards the signals. Note the signal wires carried on concrete posts where the pulleys are often secured to the platform face. (June 2006)

Fig. 79. Clearly the volunteers have been at work here with tidiness everywhere and tended flower beds and boat planter. The Up home signal on the right is of the co-acting type with two arms, as we saw at Thetford. (June 2006)

Reedham Junction (RJ)

Date Built	Type or Builder	No. of Levers	Ways of Working	Current Status 2015	Listed Y/N
1904	GE Type 7	60	AB, TB	Active	N

Fig. 80 and Reedham Junction signal box is a mere youngster at just over a 110 years old. Note how the point rodding coming out of the box front misses the carefully placed concrete sleepers. (April 2015)

Reedham is a village on the north bank of the river Yare, as is Cantley, but here there is a crossing point for the railway, as we shall see later.

Reedham Junction station is 12 miles 13 chains (19.57 km) from Norwich Thorpe station.

Fig. 81. The line to Yarmouth Vauxhall is top-left of the picture and this is the other one of the single track lines to Yarmouth worked by Tokenless Block. We have already seen the line through Acle from Brundall. The two tracks to and from Lowestoft curve away to the right. The Down home and distant signal on the concrete ex-LNER post are on the opposite side to normal for sighting reasons. The propane cylinder store is similar to the one at Acle and the GSM-R mobile phone mast is an indicator that there is a signal box nearby. (April 2015).

Fig. 82. On the platform now and the place looks like a guards' depot ready for inspection, it is so tidy and ordered. The spring planting in the tubs is being watered by the volunteer on the far platform. (April 2015)

Fig. 83. The view is looking back towards Cantley and Norwich. The junction signal on the right also has sighting issues thanks to the road overbridge up ahead. In the days when tablets were in use for the single line, the apparatus was by the junction signal.

The refuge siding that is running behind the box once had a spur that went to a cattle loading dock just by the station platform on the left; note how now the point for the spur has been cut back to be a trap point for the siding. Also noteworthy is how the stools for the point rodding, heading for the station, have been cut back from several to two. (April 2015)

Fig. 84. Finally at Reedham Junction is the double track to Norwich and the British Sugar works at Cantley is in the background. (April 2015)

62

Reedham Swing Bridge (RB)

Date Built	Type or Builder	No. of Levers	Ways of Working	Current Status 2015	Listed Y/N
1904	GE Type 7	12	AB	Active	N

Reedham Swing Bridge and the box date from the line's doubling in 1904. The bridge was required because the Norfolk wherries' masts were too tall to fit under a conventional bridge. The bridge is opened about 1,300 times a year and seems likely to escape the forthcoming (as of the time of writing) signal box cull in 2016, as the prospect of opening the bridge from Romford in Essex where the signalling centre will be seems to present difficulties.

Fig 85. The box happily does not rotate but the bridge does. One red flag is a message to shipping that the bridge could open, providing no train is approaching. Two red flags mean that the bridge is inoperable. There are no other flag options for boats. The box contains the bridge operating equipment. (June 2006)

Fig. 86. The floodlights we have been seeing adorning signal boxes so far may have seemed of minimal utility until now. It is surprising that the extra weight of a brick-built box has been preferred to a wooden box of the type we saw at Cantley. The view is towards Lowestoft. (June 2006)

Reedham Swing Bridge signal box is 13 miles 7 chains (21.06 km) from Norwich Thorpe station.

Somerleyton Swing Bridge (SB)

Date Built	Type or Builder	No. of Levers	Ways of Working	Current Status 2015	Listed Y/N
1904	GE Type 7	14	AB	Active	N

Somerleyton Swing Bridge spans the River Waveney on the Norfolk/Suffolk border and the signal box controls the nearby station signalling, as well as the bridge.

Fig. 87 depicts the approaches towards the swing bridge looking back to Reedham Junction and Norwich. The ex-LNER concrete posted signal is getting assistance from the rusty guy pole and wires, which look considerably less healthy than itself. (June 2006)

65

Fig. 88. This figure shows the box itself as a chunky structure for only fourteen levers, and perhaps a more immoveable one, but it also accommodates the bridge-operating mechanism. The sign on the bridge in front of the box windows reads 'Bridge Will Open'. There are other boards that the signaller can slide out to indicate a delay time in minutes. (June 2006)

Fig. 89 is back at Somerleyton station with the bridge and box in the background. Another ex-LNER concrete posted home signal as the Up starter. Somewhat less structured gardening than Reedham Junction, but attractive nonetheless. (June 2006)

Fig. 90 is the view towards Lowestoft and the Down home signal that is off is on the wrong side of the tracks, which is another train driver sighting issue. It is also inclined at an angle towards the camera. The cut down Up home is on the right side though, with the rear of its black sighting board on view. The trailing crossover would appear to be out of use as there are no signals to control a reversing move over it, unless it was done manually with flags or lamp. (June 2006)

Somerleyton Swing Bridge signal box is 17 miles 60 chains (28.57 km) from Norwich Thorpe station.

Oulton Broad North Station (OB)

Date Built	Type or Builder	No. of Levers	Ways of Working	Current Status 2015	Listed Y/N
circa 1901	GE Type 7	35	AB, RETB	Active	N

Oulton Broad North station itself is the junction of the double track Norwich to Lowestoft and the single track to Saxmundham and southwards. It is on the single track branch that the Oulton Broad Swing Bridge signal box is located.

Oulton Broad North station is 22 miles 6 chains (35.53 km) from Norwich Thorpe station.

Fig. 91 is Oulton Broad Station box and there is only the walkway at first floor level that has not been plasticised. The aerial on the outside attached to the walkway is the Radio Electronic Token Block system that supervises the single track branch at the survey date. The control point for that system is at Saxmundham signal box and this form of signalling will be covered there. (June 2006)

Fig. 92 is the view from Platform 2 towards Somerleyton and Norwich – the Up direction. The station buildings and canopy on the Down side survive in fine fettle and the volunteers have been busy with the planter tubs. (June 2006)

Fig. 93 is the view – still on Platform 2 – of the route to Lowestoft with the branch to the East Suffolk line going off to the right behind the equally overgrown Platform 1. Note how the junction bracket signal has been renewed but in a different position, as the original armless posts are beyond the bridge. In the far distance is a distant signal low down on the post so it can be seen through the bridge. (June 2006)

Lowestoft (L)

Date Built	Type or Builder	No. of Levers	Ways of Working	Current Status 2015	Listed Y/N
1885	GE Type 6	61	AB	Active	N

Fig. 94 depicts Lowestoft signal box and, since the decline of the fish and freight traffic, it must be using a fraction of the original facilities. The locking frame room and windows have been bricked in – a common precaution in the Second World War to minimise the effects of blast damage from a bomb exploding nearby. (April 2015)

As with Great Yarmouth, the fishing has been replaced by North Sea gas support and, latterly, by renewable energy infrastructure. The station was neglected over the years and the town's MP has campaigned for an upgrade. The station still proclaims in BR Eastern Region enamel dark blue 'BRITISH RAILWAYS LOWESTOFT CENTRAL' in retro 1950s style.

Fig. 95 and the three starter signals for the remaining platforms are on view. From right to left it is 2, 3, and 4. The sidings on the left are termed the 'fish sidings' and to the left of them are the 'freight sidings'. To the left of the freight sidings is the inner harbour. There are two subsidiary armed signals there as well as ground discs. The starter signal for Platform 3 is off for a DMU departure. (April 2015)

Fig. 96 and Abellio class 156, 156412 departs for Oulton Broad North and Norwich. The Stop board by the fish sidings says 'Obtain permission from the signalman to pass'. The incoming home signal with its back to us has a stencil box to advise which platform the train is arriving at, and a calling on arm to caution a train to advance slowly if there is already a train in the platform. (April 2015)

70

Fig. 97 sees Abellio class 156, 156418 arrive from Ipswich off the East Suffolk line, past the aforementioned home signal into Platform 2. There is no train already in the platform so the calling on arm is not needed on this occasion. (April 2015)

Fig. 98 and it is journey's end at Lowestoft. Platform 1 was on the far left and is now a car park. Platform 2 has the just-arrived class 156, 156418, and this platform is usually for East Suffolk line trains to Ipswich.

Platform 3 has the soon-to-depart class 156, 156412, which will be heading for Norwich on the Wherry Lines.

Platform 4 is to the right and Platform 5, as it would have been, is next to it with the buffer stops for it still in place. The buffer stops for two carriage sidings can also be seen on the far right. (April 2015)

Fig. 99 is the final Up signal at Lowestoft before handing over to Oulton Broad North Station box for Ipswich and Norwich. Noteworthy is the blue glass in the go or 'off' lens. The distant signal is likely to be Oulton Broad North Station's, as the latter's box is only about half a mile from the signal post. (April 2015)

Lowestoft station is 23 miles 41 chains (37.84 km) from Norwich Thorpe station and no mileage is given for Ipswich at this point.

The journey now returns to Oulton Broad North Station where we take the single track to Ipswich, which we saw at Fig. 76.

Oulton Broad Swing Bridge (--)

Date Built	Type or Builder	No. of Levers	Ways of Working	Current Status 2015	Listed Y/N
circa 1907	GE Type 7	Frame Removed	Gate	Closed	N

72

Fig. 100. Oulton Broad Swing Bridge signal box and bridge, and the box still has its nameplate, which is therefore indicative of Network Rail service. (June 2006)

Fig. 101 and Turbostar class 170, 170273 heads for Oulton Broad North Station from the Ipswich direction over Oulton Broad Swing Bridge. The box was released from Oulton Broad Station box. This meant that the locks on the swing bridge could not be withdrawn if the signals were not at danger and signals on the line could not be cleared to go or off whilst the swing bridge was unlocked. (June 2006)

At the time of the survey the box controlled only the swing bridge, whose mechanical apparatus was contained within the frame room. The signalling locking frame had been removed and donated to a preserved railway. The top half of the box was subsequently demolished and replaced by a Portakabin structure.

Oulton Broad Swing Bridge signal box is 115 miles 76 chains (186.6 km) from Liverpool Street station, London.

Saxmundham (SM)

Date Built	Type or Builder	No. of Levers	Ways of Working	Current Status 2015	Listed Y/N
1881	GE Type 2+	IFS Panel & VDU	RETB, then TCB	Active	N

Fig. 102 and a soggy Saxmundham box displays signal SM1 with the notice attached, which commands drivers to 'Stop Obtain Token'. The box unusually has a tiled rather than slated roof and stone blocks on the ground floor. (July 2007)

Deeper into Suffolk now and Saxmundham is an ancient market town mentioned in the Domesday Book. The coast is only five miles away and Sizewell nuclear power station has a branch line nearby for Direct Rail Services nuclear flask trains.

At the survey date the box worked Radio Electronic Token Block (RETB).

RETB Operation

In the Victorian method of token operation, a physical token is issued to the train driver that is specific to that section of track. That token acts as the driver's authority to proceed on that section of track and no other. When the train arrives at the end of the section for

which the token is valid, the token must be surrendered and another token issued that is valid for the next section of track. It is the driver's responsibility to ensure that the correct token for the line being travelled on has been issued.

RETB is an update to the nineteenth century system where the controlling signal box – in our case Saxmundham – issues a radio signal from the box that is displayed in the train driver's cab as the 'token' for that section of track. The train driver has to press a button to acknowledge receipt of the electronic token and this is relayed back to the signal box. The section of track authorised is displayed in the cab electronically. Once the train driver has acknowledged receipt of the token, the signaller gives verbal permission over the radio to pass a STOP board and the train is then in the section for which permission has been granted and token issued. There was voice recording equipment in place of the signal register.

The radio frequencies the railway were using for RETB were withdrawn for other uses and this rendered the system redundant in England and Wales, although RETB working continues in Scotland on the West Highland line (covered in a later volume).

The East Suffolk line was converted to Track Circuit Block with axle counters in October 2012. RETB did not have the capacity to accommodate the increased frequency of trains on the line in any case and so was doubly doomed.

Saxmundham signal box is 91 miles 8 chains (146.61 km) from Liverpool Street station, London.

Fig. 103. Saxmundham station and the view is down the platforms. A STOP board, as referred to in the piece about RETB, is visible at the end of Platform 2 past the goods shed. Note the cast-iron lettering in the canopy brackets. See how the grey signal post has been placed in line with the cast-iron canopy supports and the signal head bracketed out for sighting purposes. (July 2007)

75

Ranelagh Road Crossing (–)

Date Built	Type or Builder	No. of Levers	Ways of Working	Current Status 2015	Listed Y/N
1927	LNER Non Standard	10	Gate	Closed	N

Ipswich is the county town of Suffolk and has a long history and many fine buildings. It has long been a port on the River Orwell and was a manufacturing base for firms like Ransomes and Rapier, who originally made farm machinery and ended up making railway turntables and cranes.

Ranelagh Road Crossing signal box is 56 chains (1.13 km) from Suffolk East Junction, Ipswich.

Fig 104 and Ranelagh Road Crossing signal box is the concrete-blocked hut nearest the crossing gates. The nameplate has gone but the box was still listed as active by Network Rail at the survey date. Note that there is a piece of point rodding that has been cut just by the far carrier. The gates have LNER lamps on them with the inscription 'LNER – GE'. The gates are manually operated at this time, but interlocked to the signalling. The view is towards the main line and a yard that frequently sees container trains. Behind the camera is the line to the former docks, where there were a group of sidings. The building next to the camera is a standard LNER/BR concrete prefabricated building, probably of the 1950s. (July 2007)

Fig. 105 and the LNER posted bracket signal had another destination, judging from the vacant doll or post. (July 2007)

Ely and Cambridge to Stowmarket

Fig. 106 Ely and Cambridge to Stowmarket.

The schematic not-to-scale diagram at Fig. 106 displays a valley of some mechanical signalling between two main lines and, as this journey heads southwards, the picture is patchy. The journey begins near to the cloistered confines of Cambridge University and heads across fine farmland through the ancient and delightful town of Bury St. Edmunds to Stowmarket.

Dullingham (DH)

Date Built	Type or Builder	No. of Levers	Ways of Working	Current Status 2015	Listed Y/N
1883	GE Type 3/4	IFS Panel	TCB, TB	Active	N

Fig 107 and Dullingham has no mechanical signalling but still looks the heritage part, enhanced by the brick-built storehouse to the right of the box, which was still in use at the survey date. (July 2006)

78

Fig 108 and, whilst Dullingham's signalling has been modernised, the crossing gates were manually worked at the survey date. The view is towards Chippenham Junction and Stowmarket. (July 2006)

Dullingham in Cambridgeshire is a village listed in the Domesday Book and has prospered as a commuter village for Cambridge and Newmarket.

This unlikely single track line is worked Track Circuit Block from Cambridge and Tokenless Block to Chippenham Junction signal box.

Dullingham station is 10 miles 54 chains (17.18 km) from the junction with the Cambridge main line.

Chippenham Junction (CM)

Date Built	Type or Builder	No. of Levers	Ways of Working	Current Status 2015	Listed Y/N
1921 circa	GE Type Non Standard	16	TCB, TB, AB	Active	N

The box works Tokenless Block to Dullingham, Absolute Block to Kennet, and Track Circuit Block towards Ely. The box was only recently modernised and mains electricity brought to the site. It relied on bottled gas for heating and battery cabinets for electrical power.

Chippenham Junction is 16 miles 4 chains (25.83 km) from Cambridge Coldham Lane.

Fig. 109 and Chippenham Junction box is depicted right by the line to Dullingham, whilst the tracks curve away towards Kennett and Stowmarket. (July 2006)

Kennett (K)

Date Built	Type or Builder	No. of Levers	Ways of Working	Current Status 2015	Listed Y/N
1880	GE Type 2	17	AB	Active	N

Kennett in Cambridgeshire was an early fording place for the river of the same name.
Kennett station is 18 miles 69 chains (30.36 km) from Cambridge Coldham Lane.

Fig. 110 and an all-timber box and the characteristic overhanging GE eaves are present. This was an early feature of Evans O'Donnell Co.'s signal boxes that was perpetuated on Barry signal box on the Barry Railway in South Wales. (July 2006)

80

Fig. 111 shows us a view westwards towards Chippenham Junction. Here the line runs parallel to the main A14 trunk road that heads southeast to the ports of Harwich and Felixstowe. (July 2006)

Bury St. Edmunds Yard (BY)

Date Built	Type or Builder	No. of Levers	Ways of Working	Current Status 2015	Listed Y/N
1888	GE Type 2	53	AB, TCB	Active	Y

Fig. 112 shows Bury St. Edmunds Yard signal box in colourful guise, slated for closure in 2017; the news of Grade II listing was almost in the nick of time in 2013.

Note the contrast between the manual point lever and the modern ultra-bright LED ground signal. The yard in the title has been reduced to a few sidings, mainly for track maintenance purposes. (April 2015)

Fig. 113 and part of the handsome station building designed by Sancton Wood, who also designed Cambridge and Ipswich stations, as well as some in Ireland. The Abellio class 170, 170 202 is westward-bound in the Kennet direction. There is still the remains of a steam-age water tower at the station. (April 2015)

Into Constable's Suffolk now and Bury St. Edmunds has long been a hub in this mainly agricultural area, and the processing of sugar beet into Silver Spoon sugar still goes on, although it no longer provides traffic for the railway. Greene King is a well-known East Anglian beer brand and malting and brewing make up part of the economic staple of the town. There are many fine and ancient buildings in Bury, as it is popularly known.

There is no mechanical signalling here at Bury St. Edmunds and the box is an anachronistic survivor of when Bury was a throbbing railway town with extensive freight facilities, as well as busy passenger trains.

In 2017 the yard and station are scheduled to be controlled from the Regional Control Centre at Romford in Essex.

Bury St. Edmunds station is 28 miles 44 chains (45.95 km) from Cambridge Coldham Lane.

Stowmarket (–)

Date Built	Type or Builder	No. of Levers	Ways of Working	Current Status 2015	Listed Y/N
1882	GE Type 2	IFS Panel	Gate	Active	N

Stowmarket is a delightful if quiet market town that is rapidly growing thanks to the current vogue of rail commuting.

Stowmarket signal box faces the same operational sentence as Bury St. Edmunds but without the structural reprieve.

Stowmarket station is 80 miles 46 chains (129.67 km) from London Liverpool Street station.

This completes our journeys in East Anglia and the focus switches to Essex and the Colchester to Clacton line.

Fig. 114 and the box is now simply a gate box handling the road and railway traffic where they cross. What looks like the former goods shed, in the same brick style as the box, is surviving just in shot down the line, although not now in railway use. In 25 kV system areas it was the practice to apply wire mesh guards to all track-facing windows, but Stowmarket signal box is spared these depredations – at least at the survey date. (July 2006)

Fig. 115. The station is an architectural delight in the Jacobean style, with some ends reminiscent of the Dutch style by Frederick Barnes, and is Grade II listed. What a sense of optimism and wealth promoted the self-confidence to endow Stowmarket station with such architectural riches. (July 2006)

Colchester to Clacton

Fig. 116 Colchester to Clacton.

The schematic not-to-scale diagram at Fig. 116 starts our journey at East Gate Colchester and moves across Essex to split into two at Thorpe-le-Soken. There is one double track line to Clacton on Sea and the other a single line to Walton-on-the-Naze.

Colchester has been known since Roman times as *Camulodunum* and is a thriving and growing town with good transport links.

East Gate Junction Colchester (–)

Date Built	Type or Builder	No. of Levers	Ways of Working	Current Status 2015	Listed Y/N
1924	LNER Type 2	35/Panel	TCB	Closed 2009	N

Fig.117. The half-timbered look is just as at home in the suburbia of the 1920s and 1930s, as well as Tudor times. The box operated a panel as far as Thorpe-le-Soken and interfaced with Colchester Power signal box. (October 2008)

84

This signal box at East Gate Junction Colchester is one of the few that was specifically built to harmonise with its fifteenth/sixteenth century surroundings, although it was built relatively recently by the LNER in 1924. The box was functionally replaced by a workstation in Colchester Power box in 2009 and all other boxes except Clacton were closed.

Fig. 118 and side view of the box showing some manually operated points together with 25 kV AC infrastructure as well as colour light signalling. The cottage next-door with the East Street nameplate is the cottage with which the signal box was designed to be simpatico with. (October 2008)

85

East Gate Junction signal box is 53 miles 14 chains (85.58 km) from London Liverpool Street station.

Alresford (–)

Date Built	Type or Builder	No. of Levers	Ways of Working	Current Status 2015	Listed Y/N
18?? Not known	GE Hut	Panel	Gate Box	Closed 2009	N

Yet another English place name that railway enthusiasts at least will recognise as being a station on the Watercress Line in Hampshire.

The signaller had responsibility for the road crossing. In addition, the signaller sold tickets at the local ticket office, as well as handling the home and distant signals for the signal box. A signaller by the name of Edward Burbage fulfilled this role for fifty years.

Alresford signal box is 57 miles 71 chains (93.16 km) from London Liverpool Street station.

Fig. 119 and the gate box of Alresford is in a time warp with the horse shoe above the box door. These totems would be popularly employed in the nineteenth century and perhaps until the 1960s. (October 2008)

Fig. 120 and the station building is in fine fettle if not actually in use at the survey date. It is to-let at the time of writing, in 2015. (October 2008)

Thorrington (T)

Date Built	Type or Builder	No. of Levers	Ways of Working	Current Status 2015	Listed Y/N
18??	GE Hut	3	Gate Box	Closed 2009	N

Thorrington is on a tributary of the River Colne and has a tidal mill that derives its power from local fluctuations.

Thorrington signal box is 59 miles 42 chains (95.8 km) from London Liverpool Street station.

Fig. 121 and Thorrington gate box is an unremarkable building that was used to control the manual crossing gates, also partly in the picture. The crossing gates themselves would appear to be of LNER origin. (October 2008)

Thorpe-le-Soken (–)

Date Built	Type or Builder	No. of Levers	Ways of Working	Current Status 2015	Listed Y/N
1882	GE Type 2	IFS Panel	TCB	Closed 2009	N

Thorpe-le-Soken was originally an estate village in service to Thorpe Hall but has now evolved with a separate identity as a commuter town.

The station is also a junction where the double track main line from Colchester arrives, but leaves as two lines to Clacton and Walton-on-Naze.

Fig. 122 and Thorpe-le-Soken signal box is melded into the station buildings on the island platform. The box is clearly an LNER modernised building, in 1941, but has retained its walkway with cast-iron brackets. The platform the camera is on is no longer in use for trains as Platform 3, but passengers access the island platforms 1 and 2. The view is towards Colchester. (October 2008)

Thorpe-le-Soken signal box is 65 miles 7 chains (104.75 km) from London Liverpool Street station.

Fig. 123 and the view up the island platform with a 1930s-era LNER footbridge bridging the in-use island platform and the out-of-use main platform. Sectional buildings from cast concrete sections were popularised by the Southern Railway in the 1930s, and taken up by the LNER and then the LMS. (October 2008)

Clacton (C)

Date Built	Type or Builder	No. of Levers	Ways of Working	Current Status 2015	Listed Y/N
1891	GE Type 7	52	TCB	Active	N

Clacton on Sea has long been a commuter town for London, as well as one of the best known day tripper resorts around the capital. In 1937 Clacton was host to the second of the Billy Butlin's holiday camps, but saw its greatest visitor numbers between the 1950s and 1970s. In the early days the pier also was host to boats bringing visitors, but the railways made mass influx easy and regular.

Fig. 124 and Clacton signal box is a considerable piece of real estate and 'under the wires' even retains some mechanical signalling. Note the point rodding emerging from the box and bullhead keyed and chaired track. The box has been heavily plasticised and kitted out with galvanised steps, but retains the cast-iron walkway brackets. (October 2008)

Clacton signal box is 69 miles 42 chains (111.89 km) from London Liverpool Street station.

This effectively ends our journey down the 'Sunshine Coast' line and we now branch out to the other surviving signal box at the survey date – Frinton on Sea.

Fig. 125 and some of the mechanical signalling is in view with a semaphore starter signal and elevated ground disc over by the carriage sidings, as well as quite a few semaphore ground discs. Note the scissors crossover that gives equal access to platforms from or to either running line. (October 2008)

Fig. 126 is a signalling oddity in that the two colour light signals are of the 1960s searchlight pattern and now rare survivors. The elevated ground discs for moves to the carriage sidings are also rare beasts in that they do not have spectacles and lens for night work, but a lamp shining directly on the signal face. The ground discs are thought to be LNER items. (October 2008)

Frinton on Sea (–)

Date Built	Type or Builder	No. of Levers	Ways of Working	Current Status 2015	Listed Y/N
1924	GE Type 2	15	Gate	Closed 2009	N

Frinton on Sea was developed very differently to its neighbour Clacton in that no public houses were tolerated until 2000.

When the gates were removed in 2009, a band of about 100 local protesters staged a demonstration.

Frinton on Sea signal box was 68 miles 78 chains (111 km) from London Liverpool Street station.

Fig. 127 and Frinton signal box resembles a large garden shed or summerhouse, but was well maintained and regarded as a landmark in the town. The gates were regarded as a kind of portcullis between the rest of the world and Frinton-on-Sea. (October 2008)

Fig. 128 is a view inside the signal box and the lever frame within. The signaller's work is centred on the two home signals with red painted levers and the gate locks with levers in brown. The station appeared to have two platforms at one time and this may explain the number of unused white levers. The circular black instrument on the block shelf tells of the imminent arrival of a train from either the Up direction to Colchester or Down to Walton-on-the-Naze. The difference in height in the unused white painted levers indicates that the smaller levers operated electrical switches rather than mechanical levers.

The emergency signalling equipment is on hand in the guise of the red flag and on the far right by the fire blanket is the signaller's Bardic lamp. A Bardic lamp is a battery-powered lamp that can display different coloured aspects. (October 2008)

Fig. 129 and work is well under way to replace one of the semaphore signals guarding the crossing gates at Frinton-on-Sea with a colour light signal, controlled from Colchester power box. The two platforms are in evidence, as well as the original station building. There is another LNER concrete footbridge decorated with un-Banksy type street art. The view is towards Colchester. (October 2008)

Fig. 130. Finally at Frinton is the partner home signal to the view at Fig. 129. This signal was never modernised, with Health and Safety hoops and ladders, and remained original to the end. (October 2008)

References and Acknowledgements

Acknowledgements

The kindness and interest shown by railway staff.

References

Books and Printed Works

The works of Adrian Vaughan – various publishers
Signalling Atlas and Signal Box Directory – Signalling Record Society
Quail Track Diagrams Parts 2 and 4 – TrackMaps
British Railways Pre-Grouping Atlas and Gazetteer – Ian Allan
LTC Rolt – Red for Danger – Pan Books

Internet Websites

Adrian the Rock's signalling pages
http://www.roscalen.com/signals

The Signalbox – John Hinson
www.signalbox.org/

Wikipedia
https://www.flickr.com/photos/nottsexminer/6903040321
http://signalboxes.com/
http://www.pastscape.org.uk/hob.aspx?hob_id=499039